ERRATA

page 10, column 2: captions for Figs. 2 and 3 should be reversed.

p. 15, c. 1: Pls. 20 and 21 should be reversed.

p. 17, c. 1: Pl. 55 should read 65.

p. 17, c. 2: the description preceding Pls. 23 and 24 should refer only to Pl. 24.

p. 18, c. 1: Pls. 8 and 9 should be reversed.

p. 19, c. 2: Pl. 43 should read 41.

p. 77, c. 2: an additional listing under Sharon Smith reads "from 'Coney Island,' 1977," SX-70.

p. 77, c. 2: the dimension of Eve Sonneman's "Len's Lunch, Clovis, N.M., 1978" is SX-70 Diptych, and "Bruce's Bar-B-Q, Oneonta, N.Y., 1978" is SX-70.

ONE
OF A
KIND

One of A Kind;

Recent Polaroid Color Photography

Preface by Belinda Rathbone
Introductory essay by Eugenia Parry Janis

David R. Godine, Publisher
Boston

One of a Kind is scheduled to travel to
the following museums and galleries:

Museum of Fine Arts, Houston, Texas

De Cordova Museum, Lincoln, Massachusetts

Minneapolis Institute of Arts, Minneapolis

University of Arizona Student Union Exhibition Hall,
Tucson, Arizona

Los Angeles Institute of Contemporary Art, Los Angeles

Corcoran Gallery of Art, Washington, D.C.

Denver Art Museum, Denver, Colorado

Art Institute of Chicago, Chicago

Published by David R. Godine, Publisher, Inc.
306 Dartmouth Street
Boston, Massachusetts 02116

Library of Congress Catalog Number: 79-50785

ISBN: 0-87923-289-7

Polaroid, Polacolor, and SX-70 are registered trademarks
of Polaroid Corporation, Cambridge, Mass.

Preface

In recent years private corporations have played a significant role as patrons of the arts. In the case of Polaroid Corporation, art patronage has taken advantage of an opportunity dependent upon the nature of the product it produces. By actively encouraging the use of its materials among artists, Polaroid Corporation, as much as the patron, has become the beneficiary of a highly original insight into its own product. Who could better define the radical difference between Polaroid Land film and its conventional counterparts than the contemporary artist, for whom the message is, in large part, dependent on the medium?

Since 1945, when Ansel Adams was asked to be an artist/consultant to Polaroid, the Corporation has developed a mutually stimulating relationship with creative photographers. By encouraging such a relationship Polaroid Corporation has actually become an incomparable resource for the study of creative Polaroid instant photography.

The selection of artists in this exhibition deliberately reflects a broad spectrum of aesthetic concerns. Perhaps it is not so surprising that the medium itself has provided the loose structure within which such disparate artists may be found compatible. At the risk of seeming arbitrary, this is an occasion to question and explore the extent to which the medium affects the artist and the artist the medium, and what this reciprocal union might yield.

Belinda Rathbone
Curator for the Exhibition

Acknowledgments

Many people at Polaroid Corporation have contributed to the actualization of this book. Samuel A. Yanes conceived of the exhibition and supported it through every phase of its development. I am indebted to those at Polaroid who were instrumental in making Polaroid materials available to artists and in seeing that their efforts were toward a successful end. John McCann, of the Polaroid Research Department, brought the experimental 20x24 camera to its present state of development and availability. JoAnn Verburg invited the artists to use the 20x24 camera and helped them achieve successful results. I would also like to thank Jay Scarpetti and Peter Bass, of the 20x24 studio, for their valuable technical assistance. Rogier Gregoire and David Mahaffey gave technical advice to photographers using 8x10 Polacolor for the first time. The successful production of this book was dependent on the expertise of Victor Cevoli, the designer, with assistance from Linda Ricci; Alison Gustafson, who guided it through production; and Gertrude Trent, who coordinated all facets.

Many people outside of Polaroid generously contributed advice. I would especially like to thank Jane Livingston, James Enyeart, Marvin Heiferman, Davis Pratt, Leland Rice, and Wendy MacNeil. I would like to express my deepest appreciation to Eugenia Parry Janis, Associate Professor of Art History at Wellesley College, for significantly enhancing this exhibition with her introductory essay. David Godine and Yong-Hee Last provided editorial assistance. Most of all, I am indebted to the contributing artists for the loan of their original Polaroid photographs and their willing cooperation in the organization of the exhibition.

B.R.

A Still Life Instinct:
The Color Photographer as Epicurean

Feel we these things? that moment we have stept
Into a sort of oneness, and our state
Is like a fleeting spirit's. But there are
Richer entanglements, enthralments far
More self-destroying, leading by degrees
To the chief intensity.
Keats, *Endymion*

A Boston antiquarian of my acquaintance has a peculiar instinct for things and their manner of arrangement. His apartment abounds in possessions; they load tabletops, fill corners and breakfronts, pave rooms and halls, floor to ceiling. The agglomeration is like that of a gigantic palette, each part functions less as a material thing than as a brushstroke, a piece of color. Two turquoise parrots, having lost their avian designation, are flicks of the brush. Gold leaf trimmed red lacquer chairs quiver in warm Venetian outlines. An enormous silver apple, with a silver apple leaf equal to its scale, catches the surrounding colors and throws them back in miniature. A low glow of artificial illumination kindles the total effect and the place resounds, Berlioz-like, as an ensemble of voices in hues and tints from a thousand glimmering objects.

Don't ask the creator of these rooms, this painter with objects, where anything comes from, its century, its maker, the history of its style and shape. Is it Italian? French sixteenth century? A nineteenth century copy? For the court or for the merchant? Folk art of America or a Dutch toy? Billboard or headboard? He can't tell you. He doesn't care. Classification means nothing. Accumulation is everything. The delight is in the thing as shape, color, arabesque, sheen, incandescence, but especially their richer entanglements.

We are speaking of an instinct, that of the painter, but without the conventional palette. It works through still life, specially defined, not in the traditional sense of moral and morbid *vanitas* or French *nature morte*, but in the inanimate infused with new life by a conscious liberation and purification of its light and color. This instinct and its exploration through the art of the interior is closely tied to needs of the imagination. It demands gorgeous hermetic space as the first step toward artificial paradise. Such yearnings have invaded the faculties of the greatest decorators, even as they acted as painters, sculptors, architects, poets or writers. They form an ideal among certain American folk artists in the junk art of the recluse, the so-called naive. They also belong to certain contemporary color photographers.

In the past, imaginative color was a prime ingredient for those confectioners of total environments whose ecstatic dreams never strayed far from the realm of the visionary, be it in the symbolic color of Gallaplacidia's tomb, Van Gogh's bedroom at Arles, or the scorched hues of Des Esseintes's chambers. Early romantics like Gautier and Baudelaire, obsessed by the illusion of limitless possibilities in such dream palaces, swooned on their couches in the old hôtel Pimodan. Painted decor metamorphosed before their very eyes into pure color phantasmagoria and radiant color space. Like-minded, their painter contemporaries insisted on color exorcised from the confines of mere reference and began to unleash it as a primal expression of the Imagination – Baudelaire's "Queen of the Faculties." Delacroix, for example, put a red lobster into an English style still life of dead game, its

crustacean color alone sufficient to justify its logical necessity (Fig. 1). But he found the colors of his dreams in North Africa, in the light of what seemed like artificial days, and in the very things there, which became pretexts for enlarging the scope of an already prodigious palette. He remembered details with a collector's greed and invented a philosophy of having.

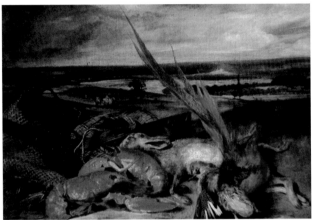
Figure 1

Colorists have always depended upon the expressive power of hue and tint as objects give off light, suggest the air of a place, structure a space. Such thinking turned some painters into insatiable amassers and accumulators of detail. Delacroix stockpiled color recollections through costume, landscape and assorted novelties in sketchbooks and travel notes. These things summoned the addled light and heat from memory later in the cool grey of the Paris studio. It was in a similar spirit of material amassment that Millais, a great pre-Raphaelite colorist in England, dramatized the idea of transcendence by creating a compendium of mad botanical precision as the setting for his *Ophelia* (Fig. 2). He sited the resurrection of innocence in a jewelled paradise of Venetian color. Among the impressionists, Renoir, trained from childhood to decorate porcelain, saw the world in a translucency of pastes, glazes and pastel opalescence. Female flesh, transparent as Limoges or Sèvres, was all the more porcelain-like enhanced by disheveled bouquets of roses, violets or marguerites. The color belonging

to these objects implicated them with all surrounding things and bound them into a network, the secret scaffolding of the colorist. In Renoir's *Luncheon of the Boating Party*, everyone is tinted pink from the striped awning overhead, enmeshed more tightly by a veil of color than by flirtatious gestures or longing glances (Fig. 3).

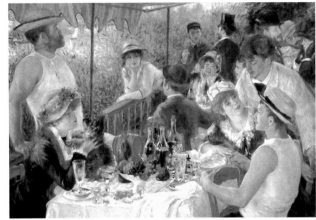
Figure 2

This art of the still life instinct, of romantic coloring with hues, tints, shades and glimmerings lodged in objects may be found in many great arts of color delectation. Much of the notable work in the present exhibition of Polaroid color operates in this mode where the sheer luxury of material surfaces has a high premium. In these photographs, whole universes may be found in spaces no larger than a corner or a tabletop. Marie Cosindas's classic style of nostalgia certainly owes its evolution to this instinct (Plates 68, 69). Olivia Parker's high Vic-

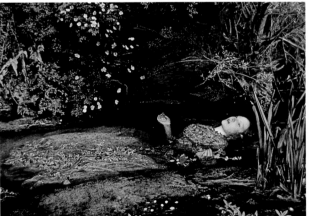
Figure 3

torian sentiments for the anima in attic clutter and delight in the treasure hunt have found new expression in the soft blush of Polaroid chromatics (Plates 66, 67).

There is another side to this instinct, and it bears upon the vision and methods of other artists exhibited here with equal force. It is contemporary and thoroughly definable as American. This art of still life dreaming emerges from the heart of our society in the strange compulsive accumulative building by the so-called American naives. These are the recluses who amass discarded objects from junkyards, railroad tracks, wherever they find them, and also build their palaces of fancy.

Simon Rodia decorated his structurally invincible Watts Towers in Los Angeles with a coating of tiles, pottery, tinted glass, seashells, broken bottles, "almost anything that would make a pattern or catch the light of the sun."[1] But the Bottle Village of Grandma Prisbrey in Santa Susana, California, really raises the tattered veil of Babylonian romance. The village consists almost entirely of bottles embedded in concrete. "Cleopatra's Bedroom," where we are told, "Grandma puts her Chinese things," is landscaped on the exterior with beds of cactus banked with automobile headlights. The spectacular "Pencil House" is hung inside with nylon curtains which mask and mute the colors of the bottles. Against it are mounted placards containing thousands of pens and pencils, their plastic color and chrome rotating with rays of light. Other writing implements assemble on a gigantic heart outlined with Christmas tree tinsel garlands (Fig. 4). On this "mountain of trivia," light is "religious in its radiance."[2] The objecthood of things gives way to light and color through sheer quantity and repetition. The thing itself is never thoroughly defined one way or another, but continues an equivocal existence somewhere between commonplace utility and its dissolution into burning brilliance.

The relatively recent rediscovery of these folk artists is part of the constant excava-tion and definition of the indigenous American arts which has intensified into a mania during the past decade. Today, in our current interpretation of the philosophy of having, our society's folk arts and artifacts are big business. The antique has given way to the collectible, and the collectible has entered into rather uncomfortable fellowship with the throwaway. The

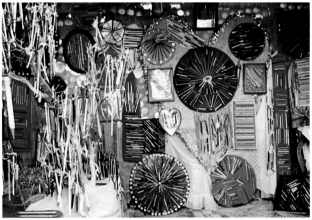
Figure 4

resonance of meaning of all these words has deepened as the American commercial explosion anxiously keeps pace with the folk art-debris trade by ingeniously contributing new artifacts to replace the old garbage in our psychological and physical landscape.

To the historicist mind of the eclectic seventies, the recluse's compulsive filing systems of objects of color and light and their complex staging have not seemed incompatible with the inveterate throwaway-collecting behavior in America at large, nor with more recent conceptions in contemporary art which mean to express a comic book history of present day American culture by symbolizing its infinitude of popular stuffs and their destiny. The made-in-America universe according to Red Grooms comes to mind as an example. Against such extravagant emporiums of seamless material unity in sculpture and film, the lifetime efforts of the naives no longer seem crackpot. Nor do they seem eccentric or outside the American scene with its plenitude of things at all levels of consumption. As the hermit naives fabricate

sanctuaries for reverie out of the American mess, their archeology outlines a moral history of the American dream with brutal poignancy and wit. Inverted and retrograde, their art nonetheless proposes a defiant radical edge. The work of certain artists working with Polaroid color in this exhibition hints at a similar spirit. Among them Lucas Samaras has responded most forcibly to the whisper of the naives and invented an utterly original photographic art.

The still life instinct has a double edge. Whether it is bound to Cosindas's nineteenth century decorator's taste for patina, old dolls and the artificial light that "paints" all things into unity, or whether it takes the form of a reclusive visionary's dream of a Kresge's Byzantium in the luster of cheap china and glassware seen through plastic color filters in Samaras's kitchen pieces, there are new points of reference being established by this interpretation of Polaroid color. Warm, airless, dreamlike, it poeticizes from the interior. Seeking to fill the photographic frame with unprecedented material richness of light, color and texture, its very inversion suggests a radical departure from the norm of contemporary photographic formalism. The historical precedent for this is not to be found exclusively in photography's own commonplace artifacts from popular culture, but in other and already suggested forms of romantic dreaming.

It is perfectly obvious to students of color that many color photographers succeed only partially or not at all because they have predetermined photography's limits to an art of prose, and estimated that color in photography must behave similarly. "The most literary of the graphic arts," Walker Evans called photography, thinking in black and white. Today in their leap into color, many photographers, hardly having cleared the barrier separating their earlier conception of photography as representation in black and white, continue to define their task as a similar affirmation of the commonplace. It hardly ever occurs to them to invent in color.

Viewed within a historical framework, this reluctance may be understood as less of a fault than as an early stage of an evolving photographic color consciousness. Emphasis on face value is an old photographic habit. Primarily, it is the residue of an attitude necessary to a particular rhetorical mode which reached its apogee during the 1930s and has dominated photographic theory and practice ever since. In the thirties, it was called documentary, and that confusing title has stuck. Today many people use it to describe all photographic work which appears to accept things as they are.

Documentary has been fundamentally important in the history of photography as a whole, particularly in America. It characterizes a good part of photography's early development in this country and defines its major achievements, from the massive effort of the portrait daguerreotypists of the 1840s and 1850s to the Civil War sketchbooks of the Brady staff, to the monumental surveys of the American West until the end of the nineteenth century. It continues in this century as well, from the triumph of photojournalism in the 1930s, with *Life* magazine and the majestic tribute to the American rural poor in the photographs of the Farm Security Administration. Both spawned a range of schools. They flourish today, having divided into numerous artistic styles, each more eloquent than the next, as nonjournalists record the contemporary American landscape, commercial strip, and social scene. Our investment in documentary is very high because it is deeply rooted in American chauvinism. It is a mode that has quite literally charted the visual discovery and affirmation of the vicissitudes of the American dream.

American devotion to documentary, the very mastery of its particular catechism and the stunning success of its adherents past and present, as they continue to be celebrated in museums and publications throughout the country,[3] contributes to the difficulty the American photographer has in coloring well. Most of

the time he misapprehends the true nature of his undertaking both relative to photography's own inherent capabilities and to color's special potential. In the process, both are diminished for many photographers do not think of color apart from the literal color of things before them. Rather than color, they vivify. The result is the predictable color-coordinated tableaus of *National Geographic* or *Arizona Highways*.

Vivification is used increasingly to enhance news reports in color which may easily backfire. The color photographs of the mass suicides in Guyana, for example, brought the events more forcibly to our consciousness than any other account. But even as it purported to describe the events as they were, the color began to act with a will of its own. The reds and pinks began to dance. The images took on a peculiarly festive quality.

The lesson from photojournalism is that color is not the same thing as *in* color. To do color justice, the artistic American photographer must evolve the physical and psychological means to control it, bring his own vision to color and create the delicately balanced situation necessary for its liberation by freeing objects without sacrificing them in the process. Finally he must be prepared to deal with color's new meaning at this stage of abstraction.

The work of William Eggleston is a good example of the American photographer caught between the documentary mode and the fantasy of the colorist. The duality in his photographs was aptly characterized as showing commonplace objects, which in their "assumed ingenuousness," did not "camouflage the artist's Faustian ambition."[4] Ultimately it is Eggleston's "Faustian ambition" that serves him best as a colorist. In the Polaroid 8 x 10 print of the sunlit interior shown in this exhibition, everything has gone green in Eggleston's alchemy (Plate 34). From an angle so oblique as to appear careless, Victorian furniture of an evil mahogany gleam reflects its grotesque gothic tracings on a wall dissolved from flatness into a space of light.

This is not a picture full of color. It is a rich union of tint and chiaroscuro that begins to deny the object, while establishing a tension in the color photograph between record and invention.

Still, American photographers on the whole have felt terribly guilty about color photography as an art. I suspect it stems from a confusion about its preeminence in advertising, against which American photography has always been defensive. By contrast, the French sally forth confident that the precedent of impressionism buttresses their art. Not a nation to fear the higher forms of delectation in all activity, they are less ashamed of it in color photography, commercial or otherwise; witness the unabashed joy in color in the recent work of Lartigue. In America during the past decade, the cloud of guilt has lifted considerably; French impressionist and symbolist color dreamings have invaded the preconceptions of artists like Eggleston or Meyerowitz. But the tradition of ambivalence toward color by many older American masters in black and white has not relieved the general uncertainty.

The color career of Walker Evans is an example of the ambivalent master. Evans earned his living as a staff photographer for *Fortune* magazine between 1945 and 1965. For nearly half his photographic career, he produced many assignments in color, not, it would seem, in a begrudging acquiescence to the demands of the Luce empire but rather in stories mostly of his own devising over which he had nearly full artistic control. After 1950, fourteen of his twenty-seven portfolios for the magazine contained all or mostly color photographs,[5] revealing that he was an inveterate collector, one of the great connoisseurs of colored objects and ephemera and through them an excellent colorist. If we are to judge by the published examples in *Fortune*, Evans's ambition to achieve color's full expressive powers was limited to his notions of good taste. Color nuance and tint in objects transformed by time appealed to him,

and as American folk artists have done, he found pastel and patina in the most monumental of American still lifes, the auto junkyard.

In a text written for *Fortune* featuring the color work of other photographers, Evans declared his position. He stated that the test of a good color photograph was "whether it would make its point in black and white." Color interpreted by the photographers under review he said, "blew you down with screeching hues alone...a bebop of electric blues, furious reds and poison greens." Color was being confused with noise.[6] Evans's outrage is not disagreement in taste but reflects a fundamental difference of interpretation. Even an eggplant may have been too much, being pigmented with "the most voluptuous and assuredly wicked color in the world."[7] Against these remarks it was genuinely surprising to discover many among the unprinted negatives in the Evans estate with a veritable "bebop" of beautiful "wicked" hues – "furious" color against which Evans had protested so vehemently. And it was in a consistent vein that on several occasions supposedly after the *Fortune* period, Evans called color photography vulgar, claiming he had not begun to photograph in color until he tried Polaroid SX-70 film in the early 1970s.[8] As color photography past and present undergoes examination, it is inevitable that its relative success as artistic expression be compared to great precedents in color in other arts throughout history. As Evans's own statements have suggested, some contradictions begin to loom. But they may be better understood if we are mindful of the larger role color has played in art in general.

Throughout history, the most profound expressions in color have been mixed with magic and mysticism. We have only to look at the stained glass of Chartres, the art of Tantra or Byzantium. Their realm is beyond our grasp, their color the primal expression of ineffability. Even in great arts of spiritual representation, such as the descriptive style of the Van Eycks in the fifteenth century, the localized jewel-like color functions metaphysically and symbolically to set off this description and question what is real. While many have secretly pondered such metaphysical ideas for photography, few have been able to achieve them convincingly in black and white, much less in color. Color's purest expression would appear to utterly contradict photography's fundamental laws, at least as they have been generally interpreted to date. The camera is an instrument theoretically guaranteed from birth to deliver up prose on command. With a tradition running straight through the center of photography's artistic and technical development which has elevated representation and prosaic visual art to their highest forms of expression – where transcendentalism is only permitted to enter in the form of enthusiastic critical metaphor – how shall the photographer do justice to the intractable, ineffable spirit of color? Color's greatest moments occur in the arts of nonrepresentation, in arts seeking to imaginatively suggest the unrepresentable, the invisible. How shall the photographer become the true poet, the mystic, the magician, the philosopher, the nonrepresenter in color? And should he even attempt the feat? Are such yearnings compatible with what has been understood all along as photography's proper sphere?

These questions continue to be posed by every photographic artist working in color, from Stephen Shore to Henry Holmes Smith. Evans demanded his "wicked and voluptuous" color from the eggplant, a commonplace object in a recordable world. No "Faustian ambition" for him. Abstraction was an impossibility, a photographic absurdity. Even accepting his logic, it is becoming increasingly clear that the persistent use of color by many kinds of photographers using diverse chemistries, manufactured or homemade, is extending its general vocabulary beyond a high art of the commonplace. And what had seemed to lie outside photography's natural expressive capacity is being expressed. Such thoughts come to mind as we embark on a closer examination of one current of this expression in America in Polaroid color

photography and the marvelous range of personalities drawn to it.

The most striking feature of the work in *One of a Kind* is its sense of material richness. A lavish array of hue and tint is revealed through a grand spectrum of materials that the color chemistry permits with the greatest possible luxuriance. This kind of color beckons the photographer epicurean and the stay-at-home. It promotes a certain definition of photographic art based less on the photographer's curiosity about the outer world and uncovering its secrets than a revelation of his own secrets through personal compilations. The photographers have been encouraged into a peculiar kind of hermeticism. As they learn to accept the rules of color on its own terms, they have been forced to exert control over it by submitting to lengthy prephotographic preparation. They fabricate the colors they need by still life arrangement. This accounts for the strong feeling that many of the best pictures were made before they became photographs.

This is an art of the recherché in every sense of the word: first, in the picture's built-in rarity as a one-of-a-kind nonreproducible associated with classic Polaroid photographic methods; secondly, in the exquisite taste peculiar to Polaroid chromatics – the blush on the rose, the warm hues of the respiring earth, well-polished wood or ordinary lamp light at evening. Roger Mertin's most notable interpretation of the chemistry seems to have consisted of little more than turning on the lights in a Cambridge apartment (Plates 32, 33). More often than not, outdoor scenes will be granted interior status, as in Sharon Smith's Coney Island beach scene, where the pink raft and sunhats detach themselves from the scene and become still life (Plate 20); or in the veritable still life of lustrous legs and feet shod in sand (Plate 21).

Finally, unlike other color chemistries, this one promotes the *search* in the extreme. Each photographer has evolved a distinct form of hunting and gathering all manner of things. It would not come as a surprise to learn that

as they worked, many had been amazed to discover in themselves this capacity for object specialization. I wonder if, before using Polaroid color, Linda Conner had imagined photography in terms of an 8 x 10 still life featuring a stuffed grackle or Japanese doodads and dried roses against Turkoman rugs (Plates 4, 5). The chemistry invites the photographer to enter into a mad material maraud, to test the whole world's texture and richness – so bring on the abalone shells! The rusty gears, yellow satin, crazy quilts, harmonicas, carnival glass, crayolas! – the bulldogs!

Associations from these objects are droll, sensual, even vicious. A strange spectrum of emotions emerges from the private reveries of the still-life arranger, far from the here and now. Don Rodan's preference for red satin, red lacquer lips and fingernails, champagne blond curls, and chrome yellow pencils turns his pictures, ostensibly personifications of ancient mythic ideas of sleep (HYPNOS), inexorability (ATROPOS), deceptiveness (AMBIDEXTRA) or self-love (NARCISSUS), into fetishistic banderillas, evil darts whose barbed sharpness is communicated precisely through photogenic selection (Plates 61-64).

Humors in another balance turn more deeply within themselves, into graver fancies that only those who remember the insistent fanatical imaginings of childhood will acknowledge as real. Before the camera, Rosamund Purcell is the painter-illustrator of the Victorian child's terror of metamorphosis where phantasms lurked in the winter garden, behind the stairs, in the very pattern of the carpet; where a gentle pussy could tear you to bits, and big sister was a butterfly or an orangutan (Plates 57-60). The mid-nineteenth-century French proto-surrealist Grandville called this world apart *Un Autre Monde*. Purcell, who is not interested in using photography to speak about our own time, but rather to express the compelling digressions of the sinister, out of time, happily passes over the bridge separating the arts into the realm of literature. In these pictures at least, she is Grandville's photographic stepchild.

Incorrigible nostalgia, antiquarianism, bookishness and the insatiable will to experiment beyond the conventional provinces of the traditional arts invade the work of these artists. In the sheer build-up of stuffs, old-fashioned sweetness and light seems almost outrageous in an art of the cupboard or the wardrobe of memory. Still life's original process and meaning are expanded as photographers round up their stuffs before the camera. Expertise culled from other arts of placement comes into play. Dollhouse arrangement is alive and well, as are other games of ordering that involve a conception of the world in symbolic miniature. Les Krims, no stranger to such arrangement using Polaroid materials, steps beyond still life to something crossing comic book and medieval illumination in a photograph of miniature toy pigs painted over in white – his Old Testament salutation to Christianity (Plate 40). John Gintoff's *Persian Versions*, assemblages of every conceivable photogenic fabric and color, have borrowed ideas of gloss and structure as much from the art of department store gift wrapping and window dressing as from collage (Plates 52, 53). Delectability, sooner appreciated in the fabrications of commercial advertisement or in grandma's handicrafts, are forcefully introduced for better or for worse. The manipulation of these things recalls arts that have seemed incompatible with American photographic ideas; wallpaper patterning for its own sake, the arts of pure design in Russian Easter egg decoration, manuscript illumination, embroidery, Japanese ukiyo-ye. In a revival of the art of bulletin board syntax, Victor Schrager reviews the entire history of world art, in the trivialized form of snatches from illuminated slides in dark classrooms. These unforgettable disengaged fragments, part of contemporary visual baggage, jump from nowhere, their original intent long having ceased to move us (Plate 56).

The picturemaking activity here is one of conjuring, elaboration, and adjustment similar to painting, a word used advisedly. How far a cry from the Spartan grandeur of the traditional American photo-documentary spirit, its celebration of fact and evidence, the absolute acceptance of what was there! But even as this work engages the imagination and visionary spirit more than we are used to in American photography, it is no less American in its expression of our culture as it has evolved, nor is this other facet of American vision any less inherently photographic. For all their allusions to a myriad of other kinds of object making, we would never confuse these fabricated pictures with anything other than photography.

Many of the photographers are painters. Others were trained to be. This only means that we may expect them to take liberties. John Reuter peeled off the emulsion to see what held the image. His pictures demonstrate how precariously the photograph holds our knowledge of the past. With old photographs as the subject, his pictures reflect upon photography's origins and the means by which they enable us to establish contact with the departed who remain vivid forever in the emulsion, encased for all time in a filament as delicate as a spider's web (Plates 54, 55).

Polaroid's materials seem to encourage play generally. Like Reuter, other artists have made it a point to ignore the instructions, refuse to confirm the preconceptions of what the result was supposed to look like. They have taken the materials apart, violated them in innumerable ways – one artist confessed to having put a couple of SX-70 prints in his toaster! What had taken years of research and development to make stable and predictable surrendered to unpredictability. The conventionally perfect was brought to a new interpretation of perfection which defined the ground rules for a peculiar art. This apparent lack of reverence is the heart's blood of artistic innovation. But it is nothing new. It accounts for what the best artist experimenters have done with the foolproof recipe since the early days of daguerreotype or calotype, which of course accounts for the vol-

ume of published variants of these processes.

Polaroid SX-70 prints recall daguerreo-type. Theoretically, the pictures are unique, and there is something about the proportions of the images that make them appealing as keepsakes. As soon as artists had enough SX-70 film to use and abuse, some began to make works of art. It started in a kind of necessary chaos of plenty. I can remember SX-70 parties where photographers, like Rumplestiltskins run amok, literally filled rooms with the photographs and where we danced to the musical sound of hundreds of electrical releases ejecting the pictures. Polacolor had been a delight, but it was the SX-70 system that created the *community* of color photographic epicureans, most of them AWOL from the zone system. In the first place, the SX-70 print was a sensuous little thing, as much a photographic object as had existed since the velvet-ensconced daguerreotype. A plump, satiny, perfectly proportioned little pod, the SX-70 print was extremely lovable. It was nice to touch. Unlike contact sheets or color slides, the image was right there fast, large and whole, unneedful of the dark room, viewing screen, light table or loup. Kenneth McGowan's frying egg sequence in four stages or that of the bathroom sink filling up comments wryly on the dynamics of the SX-70, where in seconds one can have stages of changing time (Plate 55). People liked to study their pictures by shuffling through them, making decks and packs, sequencing and resequencing, comparing, reshooting.

Like so many latter-day impressionists, one of the first things photographers discovered they could do with SX-70 was sketch. Photographers have always made visual notations with the camera, even when to do so meant carrying sixty pounds of equipment through the woods or up a trail to make just one or two pictures a day. And commercial photographers used Polacolor from its inception to make notes and test lighting conditions in throwaway sketches. But artists wanted series, collections in groups. This massing of pictures was highly dependent on the feeling that there was plenty to waste; many photographers were given that privilege.

Numerous SX-70 sketchers appear in *One of a Kind*. Peter Von Zur Muehlen makes graphic notations that seem like random samples from an enormous filing system of color observations enjoyed in passing (Plates 41-44). Benno Friedman is a nightlight sketcher making throwaways. Frame askew, these are slight ephemera from a drive in the rain. The weather provides the necessary cosmetic veil for Friedman's thoroughly translucent world, and the chemistry responds almost intuitively to the water color vision transforming an object into pure color divested of space. A stoplight, having lost its third dimension, becomes an incandescent Japanese lantern (Plate 25). Street lights organize the format with their own graphic patterns. Headlights halate on the wet street less like the iridescence of Tiffany glass than that of an oil slick (Plates 23, 24). No need to focus. The world is a hermetic blur, natureless even among the elements. Inside and outside are identical. A turquoise and magenta street corner has no more air than the little hallway of purple, green, bebop red and orange glowing like a cheap Christmas tree ornament (Plates 22, 23). Eve Sonneman thinks similarly in her sketches. A picnic cloth simply refuses to occupy space, to surround or define things, and becomes an occasion for radiance (Plate 45).

Against Friedman's and Sonneman's transparency, one of David Hockney's swimming pool sketches is almost pure light (Plates 11-14). Depicting the most primitive of lenses, it shares the qualities of Friedman's rainy streets. The swimmer at different stages of a journey through the pool, his body transformed in this archetypal act in such a primitive field, recalls a photograph's own watery origins. But Hockney is collecting ideas for use in other media, and I suspect that all these pictures are not particularly close to the heart of their maker because

of their practical function in the studio. All the same, these sketches are compelling because they operate at such a fundamental level of the photographic idea; in their very tentativeness, they are as wonderful as the first trials of Nièpce, Daguerre or Talbot.

The frame does not mean much to the SX-70 sketchers, but for so many of the other photographers here it is regarded as a container. Frank Di Perna seems to have considered every millimeter of the 3 x 3-inch field. Conceiving of it as a format to be filled and divided, he draws with the colored objects and frames them so that they graphically survey the little corners of space he prefers. Four or five degrees of whiteness, from cream to pearl to sand, may be differentiated in the view of a bedroom corner, simply by reading between the lines on the wall, on the bedstead or the wrinkles in the sheet (Plate 15). Similar color graphing and harmonizing appears in the corrugated siding painted green and cream. It is delineated with yellow curves of a new bicycle, counterbalanced by its shadow in the noon light and the single red exclamation mark from the bike's reflector (Plate 17). The opaque light and enamel-like textures of the subject matter perfectly complement the print's mylar surface. The effect is hardly a sketch. These are little tableaus. Strictly controlled in every detail, they are elegant and complete unto themselves. Like Di Perna, Jack Caspary is another field divider making tableaus. But he achieves them with bolder design, measuring the 3 x 3 through the contours of a bathing suit (Plate 9) or dividing the sky with a yellow stripe to classify the presence or lack of clouds (Plate 8).

No matter what the format size, the photographer's overriding desire with Polaroid color seems to be to stuff the frame, to embroider the field, to carpet it wall to wall. It is almost unavoidable: Joel Sternfeld's 4 x 5 Polacolor street scenes point up the urban drama of survival by his refusal to indicate a true horizon, aided by the relentless claustrophobic fabric of the scenes' color (Plates 28-31). Polaroid's per-

petually felicitous response to intricate and complex chromatics enliven Arnold Newman's 8 x 10 portrait of Roman Vishniac and his wife. It is one of the most arresting, not for a particularly incisive characterization of the sitters, but because the carpet richness of papers and books in their study rushes forward with superhuman gregariousness (Plate 3). Strange as it may seem, it is the little SX-70 format that invites maximum density. The best of these little pictures contain what would ordinarily be considered too much in them. Thick with textural activity and eye-catching accent, many are the result of deliberate disproportion between their size and what it might be expected to contain. The photographer is led into miniaturization and quickly from that to enchantment – Sharon Smith's little red fabric bazaar of tent and signs at Coney Island (Plate 18); or to enthralled disorientation – what does it matter if William Larson's night sky of yellow stars originated from a bed of marigolds?

Disorientation is even more pronounced before the new 20 x 24 view camera that is only beginning to elicit an appetite for romantic fancy. It is probably too soon to tell whether photographers will be allowed to transport the monstrous apparatus out West. One hopes so. But in the meantime, during a relatively brief period of use in Polaroid's Cambridge studios, the photographers have all they can do to fill its enormous field. Filmmaker David Haxton experiments with notions of collage. References to the photographer's studio set against the mysteries of radiant color space also recall the grandeur of Rothko in their exaltation of warm, airless radiance (Plate 46). Kenda North's colossal torsos, in a kind of "cuirass-scape" mode, allude to terrains suggested by proper selection of a Chinese brocade, Hawaiian shirt or by bizarre fields of body hair. Jan Groover stages her seamless lunar fantasies with floating cutlery. All wall to wall, never giving the air a chance, never choosing to explicitly represent even as they use recognizable objects, these photographers seem driven

into strange fictions. Michael Bishop's large scale spoofs comment on changes in proportion and the acting out encouraged by the stationary camera, and on the ultimate confusion between the thing itself and its transformation into place.

The new vision in this work belongs to the photographers who would have us believe in a completely fictitious universe of their own making. This universe is complicated, sensually rich, full of secrets and above all, as inexhaustible as the world of actual experience. Similarly, it would appear to exist in time and space beyond the confines of the frame. Objects of light and color and their arrangement produce this endless fabric. Its verification in terms of the actual is impossible, and what is more, beside the point. Granted, one can hardly resist or avoid inventorying these objects; they speak so eloquently of the personality of their compilers – Samaras likes flashlights, colored glass and knives, Groover likes forks (Grandma Prisbrey liked bottles). But verification will only account for discontinuous parts. It is the whole fabric we are concerned with. It amounts to the sum of its parts, but taken individually, they do not explain it.

With enthrallment as the goal in this photographic art, there occurs a fundamental change of attitude toward the frame beyond the simple differences in format size Polaroid film provides. It is a variation of the idea, discussed earlier, of the frame enclosing an empty field asking to be filled. In assuming the preexistence of a rich fictive world "out there," an assumption invested with certain conviction since the photographer has gone to some lengths to dream it up, for some the act of framing now becomes like the action of scissors shearing off photographic segments as if from a bolt of cloth. Traditionally, actual experience has had a similar relation to the action of the camera which in photographing produces, as the expression goes, its slices of life. But more usually, the traditional photographer does not invent his subject from scratch. In the classic

conception and procedure of photographic composition, the artist actively selects with the frame, always letting the viewer know that the slice has been granted the privilege of his special regard. In its greatest moments of interpretation, the frame plays a major structural role in turning subject matter into a "picture." With certain photographers here, this classic action of a self-contained picture synthesized by the frame has little significance.

Brian Hagiwara's witty imagery with SX-70 consists of deftly manufactured fields of pattern. His object repertory includes small scale and trim things such as oranges, dyed eggs, phonograph records, rolls of tape, razor blades, paint brushes and chopsticks. Given a consistent middle distance scale, they appear like letters in a personal alphabet. Seeming to levitate from their still-life surface, these forms hover and collide against flat fields of color or black plastic, adding their own hieroglyphic glints to the illusory calligraphy. The frame in its arbitrary placement explicitly alludes to a larger whole, and Hagiwara further promotes this continuity by grouping four images together into polyptics (Plate 51). Compared with the direct noting of actual cloth pattern as in Von Zur Muehlen's sketch of a department store model in a print dress (Plate 43), Hagiwara, with a still life of Easter egg dyeing materials has invented his own, perhaps more chic, thirties crepe-de-Chine print. The objects of his choice merge, moving in and out of their domain of the real into the realm of pure illusion. John Gintoff also expounds upon a world of personally manufactured yardage by directing nudes so that they appear to rise and fall like victims of drowning, writhing sirens caught among ocean waves of material (Plates 52, 53). With silver-tongued intricacy, William Larson's metal fabric puns extravagantly through berries, pills, saws, scissors, tin foil, and chrome whose turbulence vacillates between utility and terror (Plates 36-39). With these photographers, one image alone is not as effective or comprehensible as many seen together. Collected, their continuous

tapestry exerts a compelling force, for each segment constantly refers to the others, enriching the meaning of the total vision that originated them all.

It is Lucas Samaras's extraordinary Paracelsian designs that ultimately summarize, clarify and justify these tendencies of imagination emerging from the still life instinct in color photography. Against his work, photographs by the others also may be recognized for the originality of formal intent. Six 8 x 10 kitchen pieces by Samaras (Plates 47-50) look at first like the indiscriminate pile-ups of a Byzantine recluse – "the last Byzantine," as he called himself, until we peer more closely into the stained glass light of his sanctuary.

A butcher knife has cut open a pomegranate on a table, expelling primary colors that radiate to fill the entire room. One-half of the fruit oozing turquoise dominates the foreground, as if to symbolize color's liberation through the sacrifice of the object (Plate 50). With the simple directness of comic book heroics, we are given a wonderful riddle. The cut by the knife is the key. Samaras is the alchemist wielding his sword; Faust in the kitchen. The sensuality, like the symbolism, is specially defined, first by the power of the sword, then by the force of the elements in the ocean of writhing Egyptian courtesans (from a currently popular commercial fabric); not true flesh but graphic representation from Victorian illustration, by now many times removed from the original beings that kindled the longings of their original nineteenth-century beholder. The courtesans dance as the material is moved about in various pleats and folds to create the tossing and turning "classical" torsos, showing off breasts and bellies.

Add to this pencils, magazines, playing cards, paper clips, candy dishes, tennis racquets, flashlights, scissors, knives. Kitchen things; more properly, utensils. But it is the color that transcends them. Color is pure magic, the superpower. Samaras weaves a heroic American fabric. It is not the old familiar one, but we recognize it, the black and white comic strip with color overlay out of register. His pictures are slices of personal biographical yardage in which his present and past collide in the commonplace materiality of the junk and its genuinely mythical associations. Their beginning and ending in the frame is quite arbitrary. The Samaras self is everywhere, not only mirrored but peering out of the glassware. He is the ancient ruler of this junk palace but also its chief archaeologist. It is not surprising to meet Superman in the blue piece soaring forward in greeting or to revel in an endless supply of trophies (Plate 48). In the alchemist's domain the cookbook yields to *Scientific American*. The kitchen becomes the laboratory of life. Here the photographer has reached the "chief intensity," where everything is intricate, where all things are inextricably related.

Eugenia Parry Janis

Notes

[1]Walker Art Center, **Naives and Visionaries** (New York: E.P. Dutton, 1974), "Simon Rodia: Watts Towers" by Calvin Trillin, p. 27.

[2]*Ibid.,* "Grandma Prisbrey's Bottle Village" by Esther McCoy, p. 82.

[3]The impressive exhibition called **Courthouse**, sponsored by the Seagram Corporation, even more beautiful in book form with text by Richard Pare (Horizon 1978), and the recent republication of Robert Frank's **The Americans** in a newly magnified scale by Aperture, are the current season's more notable examples of this celebration.

[4]Museum of Modern Art, **William Eggleston's Guide**, essay by John Szarkowski (New York: Museum of Modern Art, 1976), p. 10.

[5]Wellesley College Art Museum, **Walker Evans at Fortune 1945-1965**, exhibition and catalogue by Lesley K. Baier (Wellesley: Wellesley College Art Museum, 1977), p. 20.

[6]*Ibid.* [7]*Ibid.* [8]*Ibid.*

Illustrations courtesy of: Musée du Louvre, Paris (fig. 1), Tate Gallery, London (fig. 2), The Phillips Collection, Washington, D.C. (fig. 3), Jan Wampler, Cambridge, Mass. (fig. 4)

The following photographs have been reproduced
actual size from original Polaroid prints.

The 20x24 Polacolor prints could not be
reproduced in this book actual size. Therefore we regret
that they are not included in the plates.

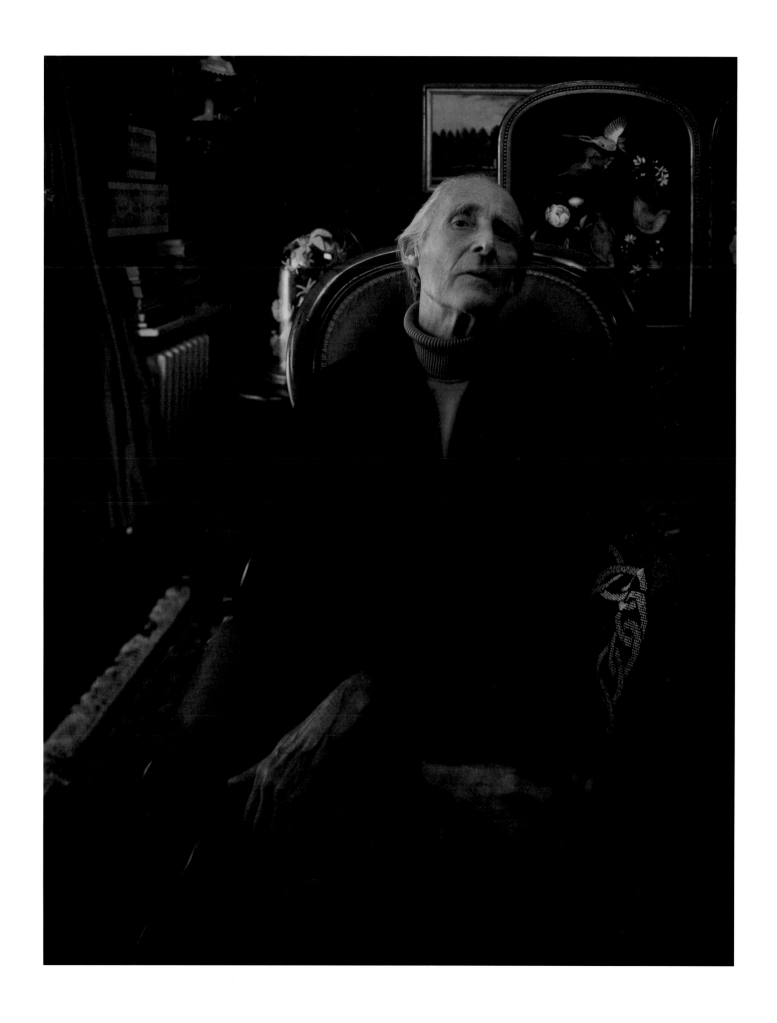

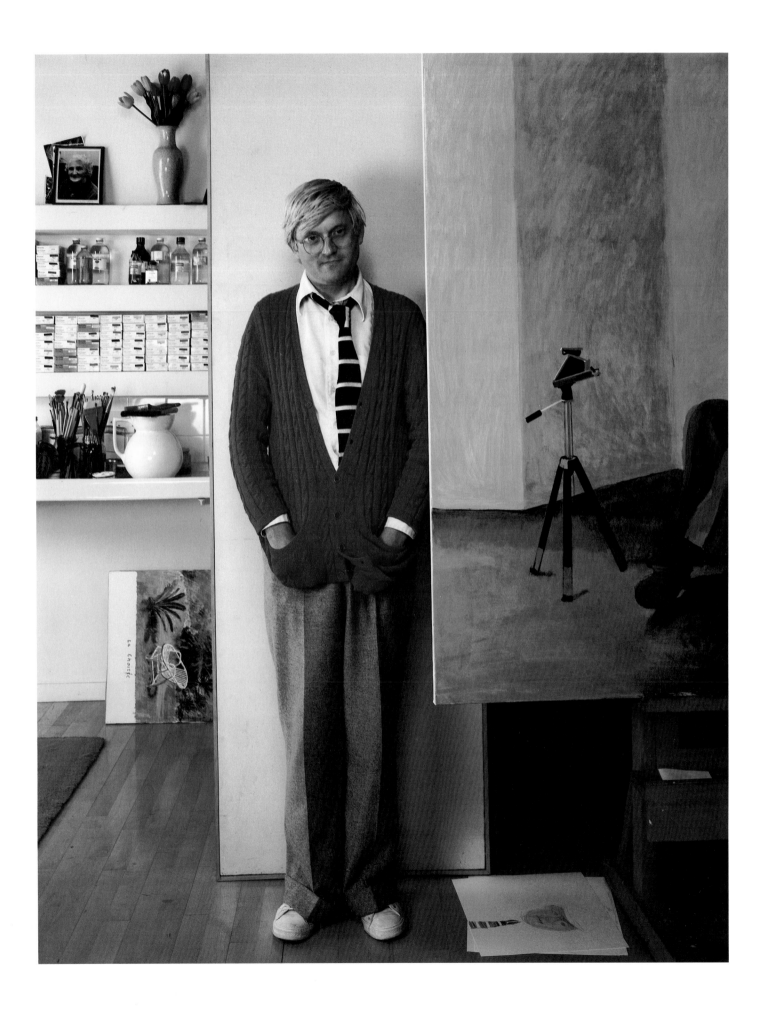

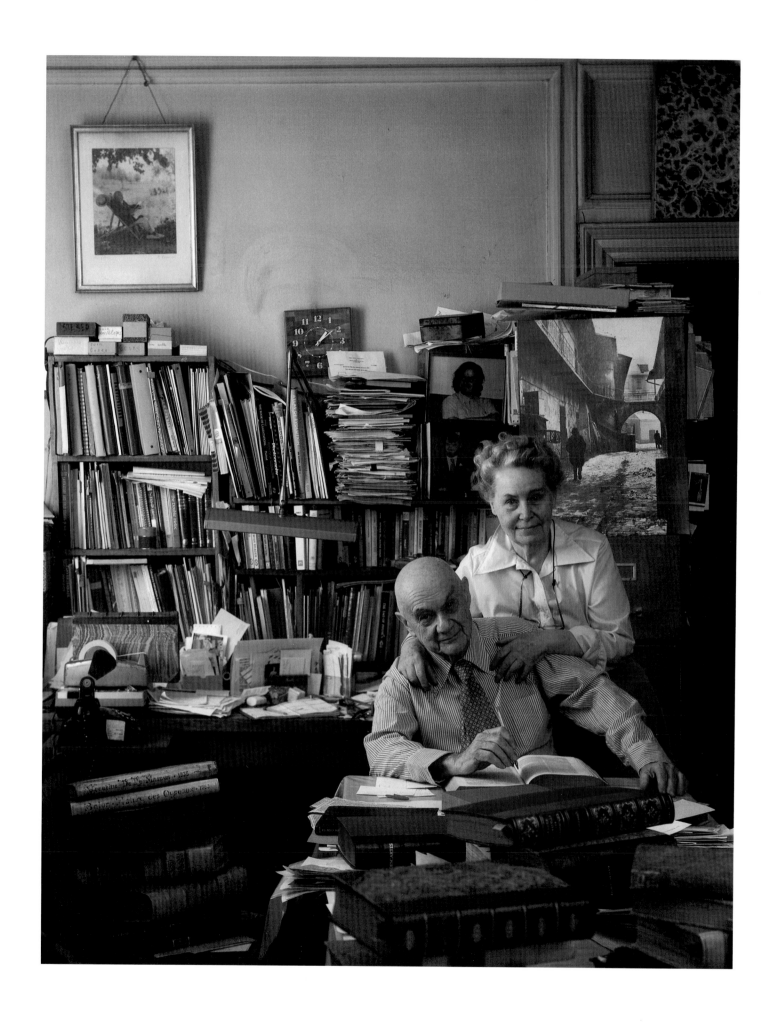

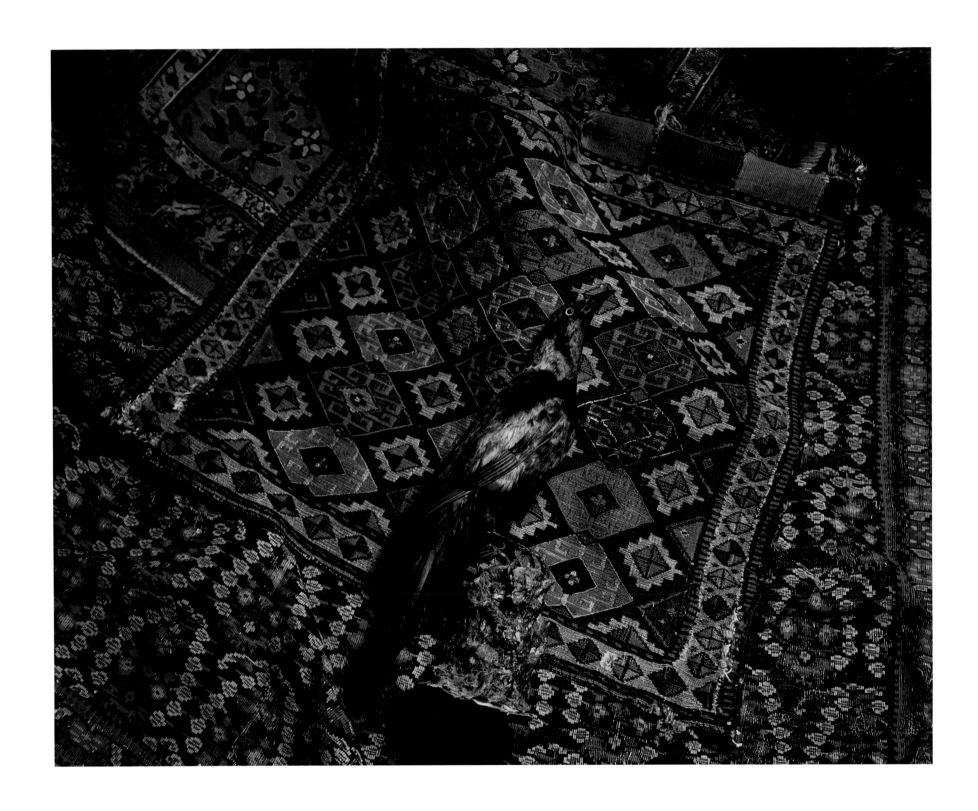

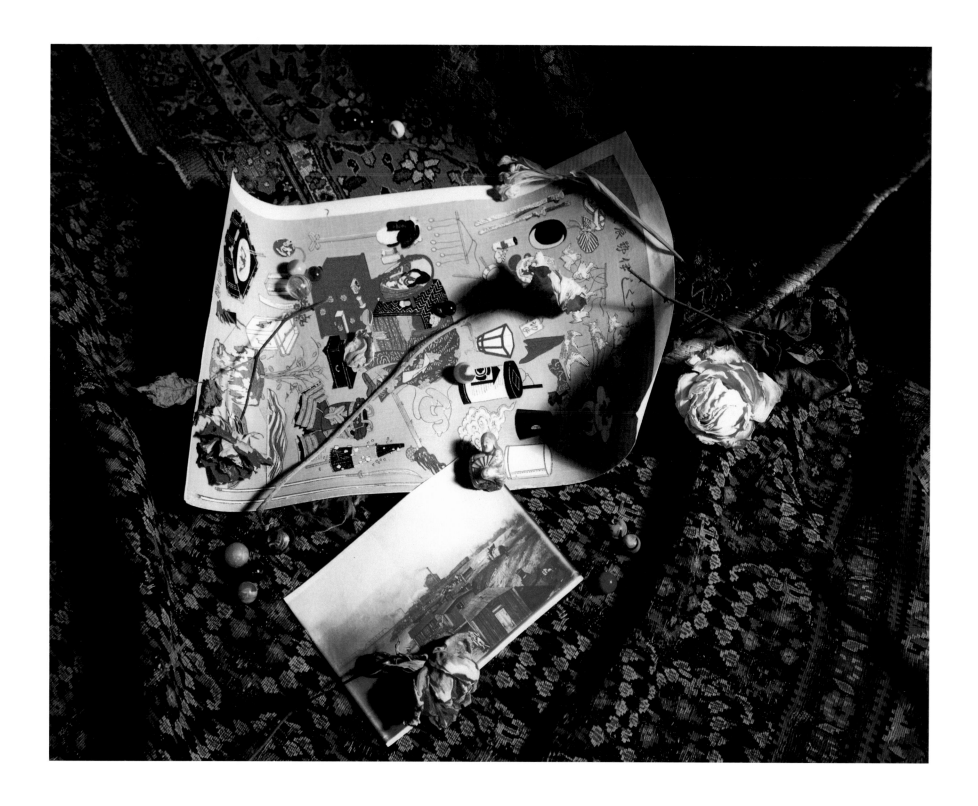

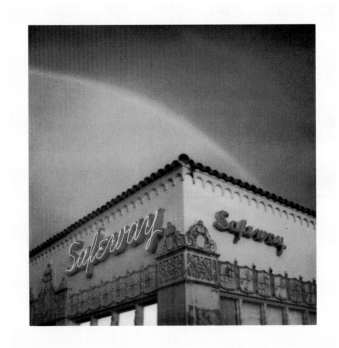

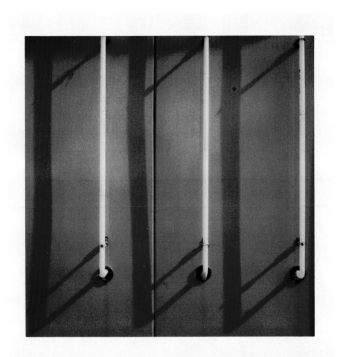

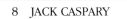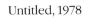

8 JACK CASPARY Untitled, 1978

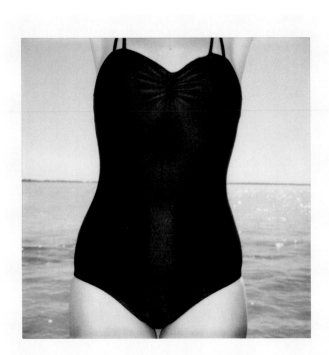

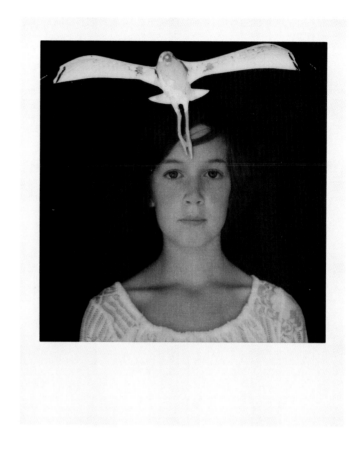

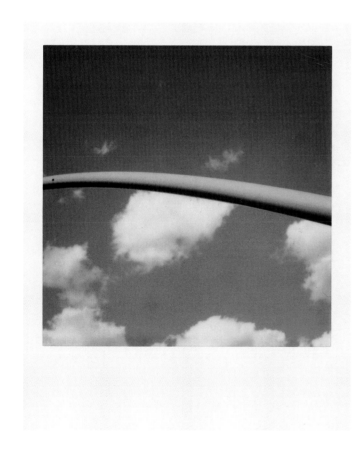

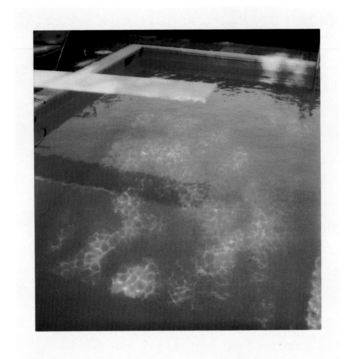

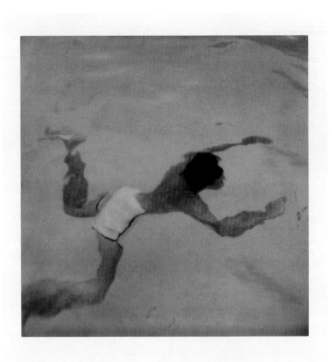

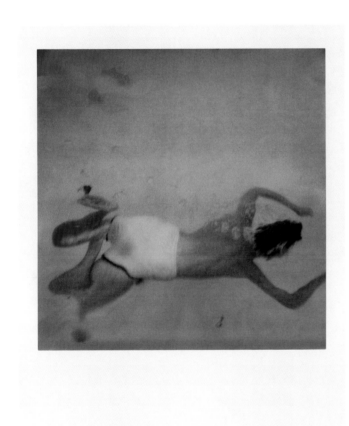

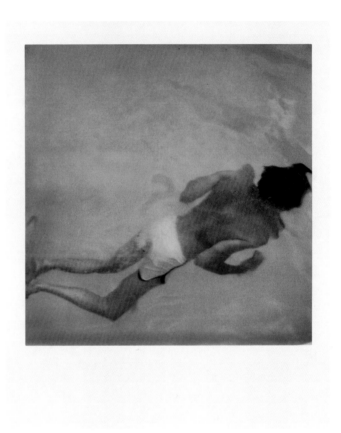

15 FRANK DI PERNA Bedroom, Tenants Harbor,
Maine, 1977

16 FRANK DI PERNA Pipe, Belfast, Maine, 1977

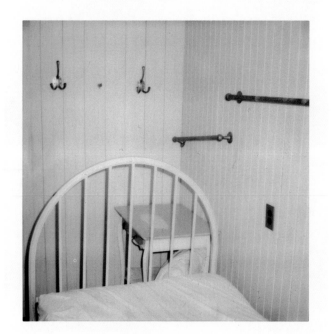

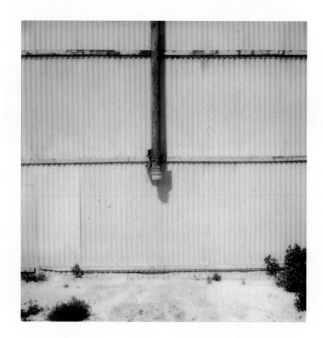

17 FRANK DI PERNA Bicycle, Rehoboth Beach,
Delaware, 1976

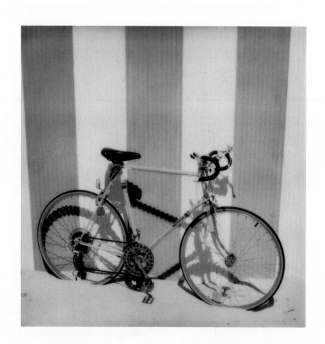

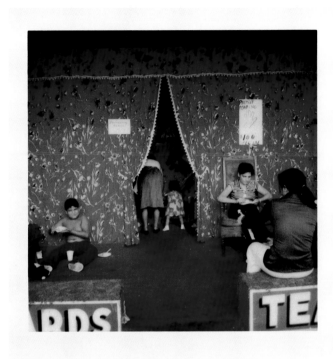

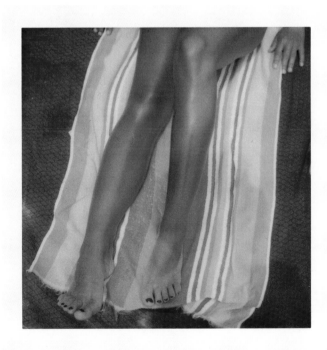

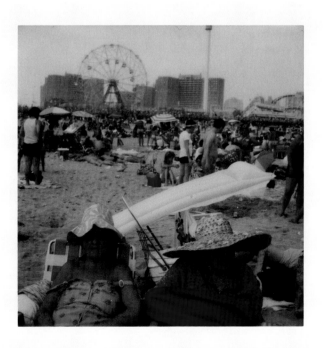

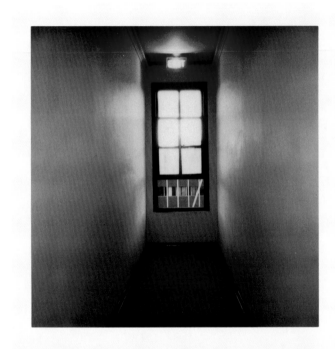

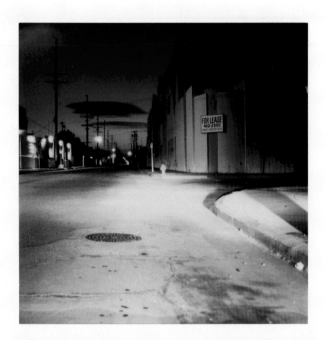

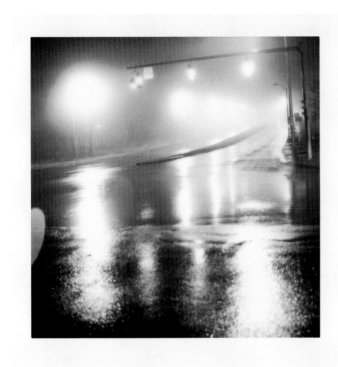

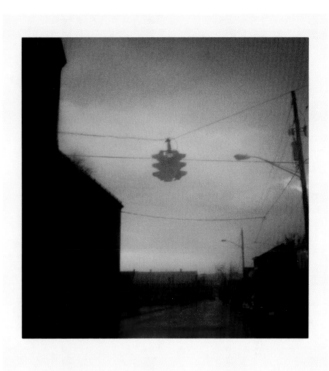

A photo of ART's Major work—
before sand blasting and
painting —red— yellow— blue
Headquarters

all this writing washes off

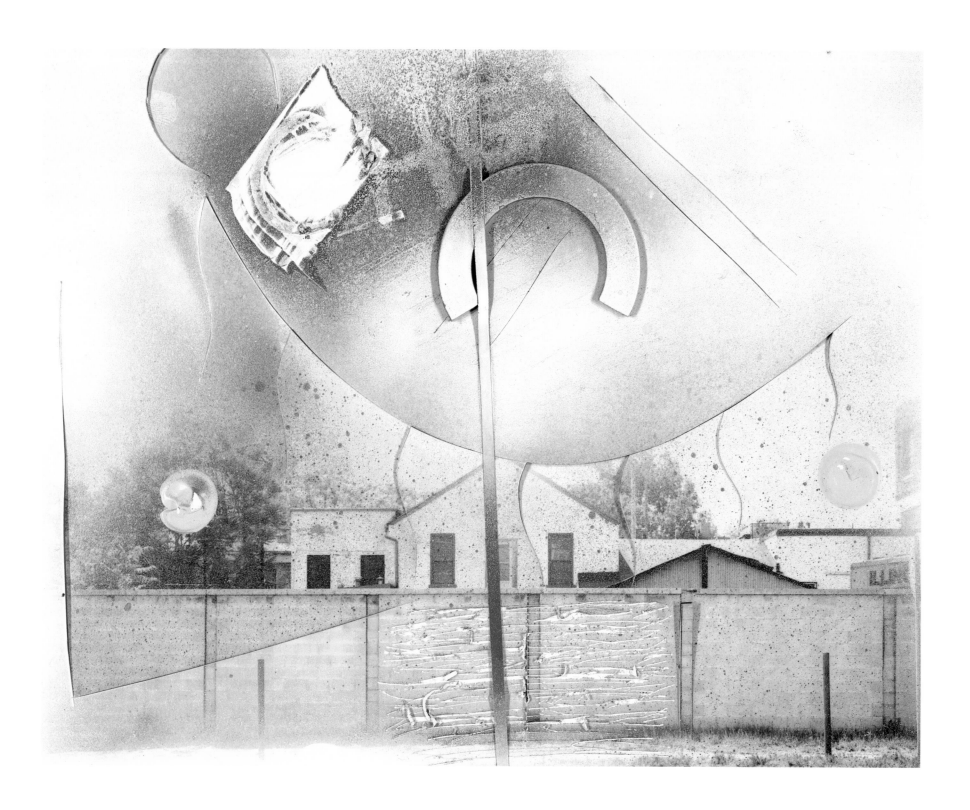

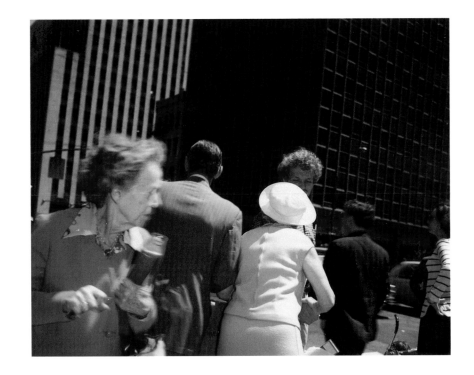

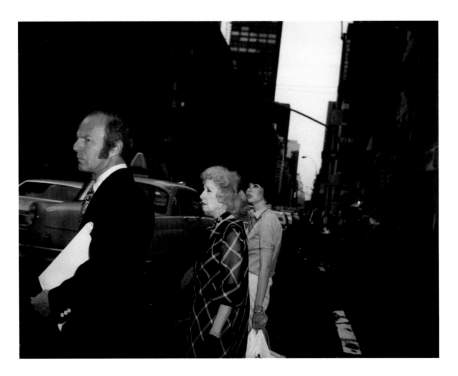

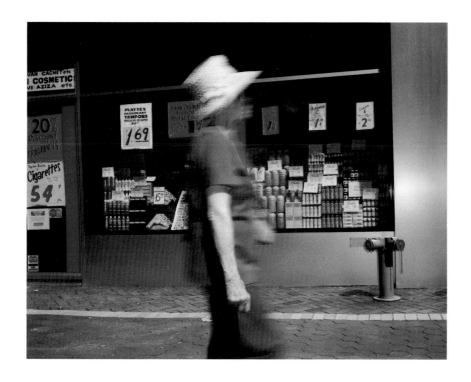

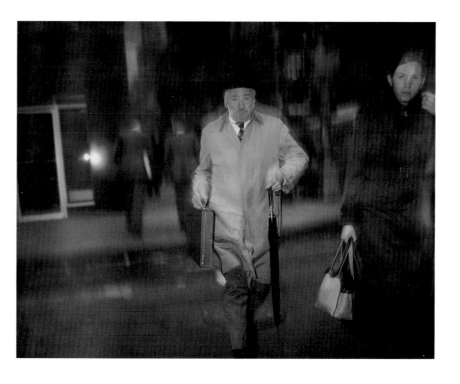

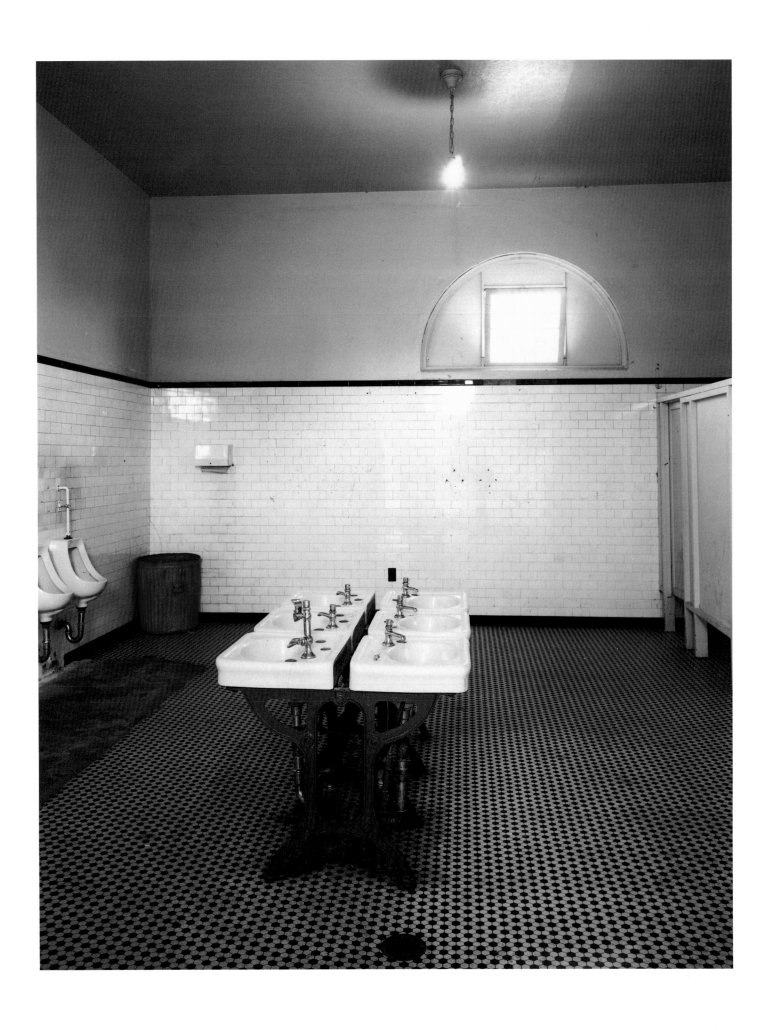

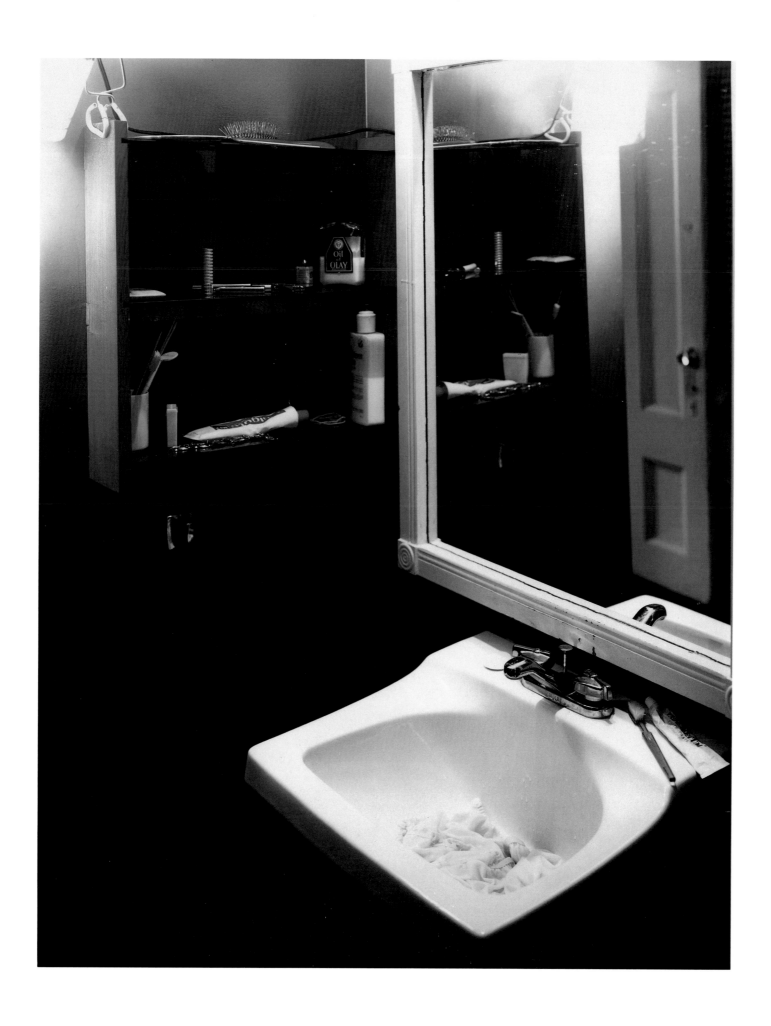

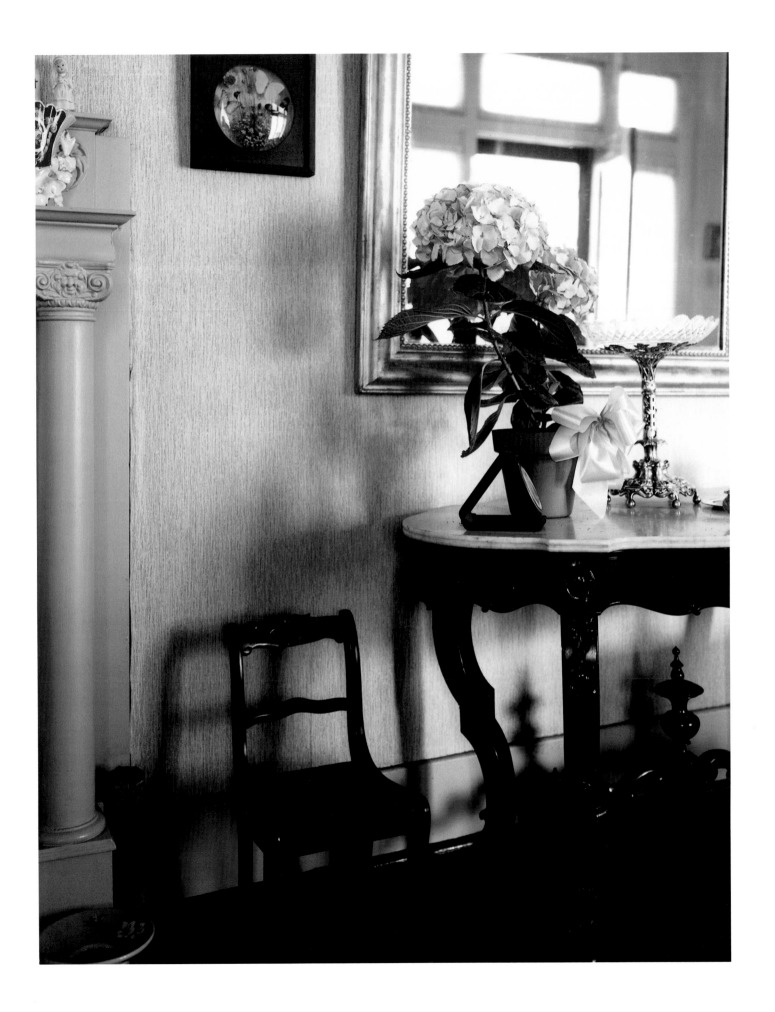

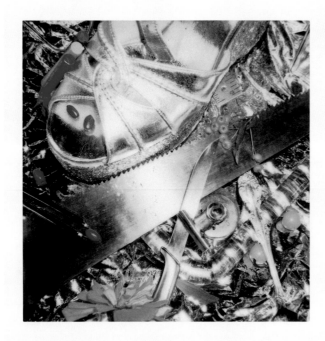

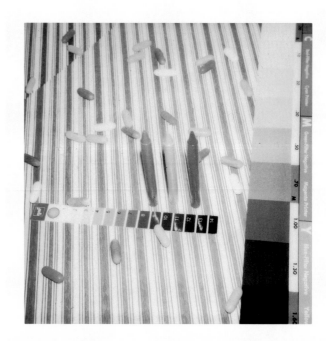

38 WILLIAM LARSON SX-70 Silver Print, 1978

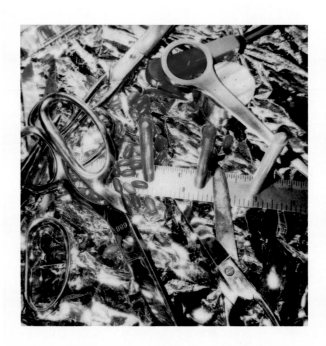

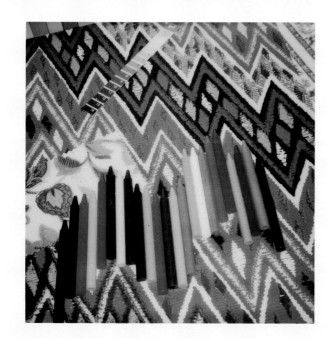

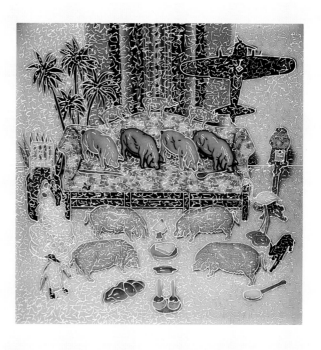

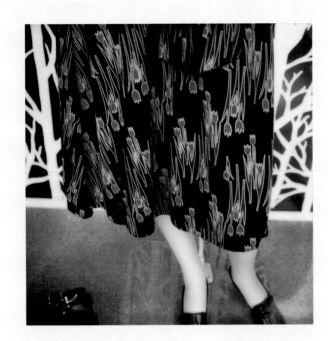

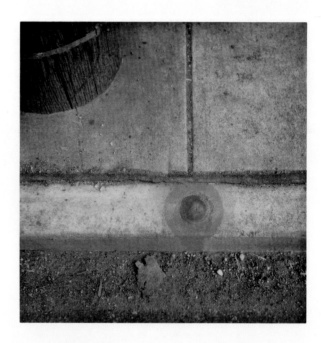

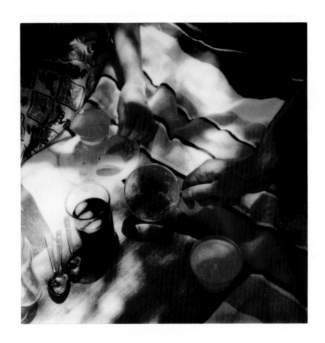 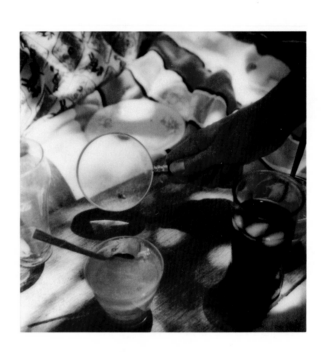

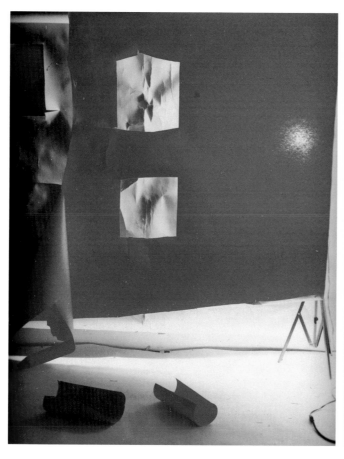 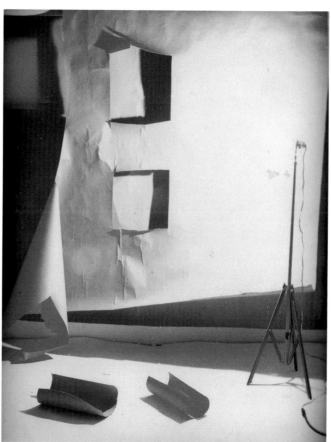

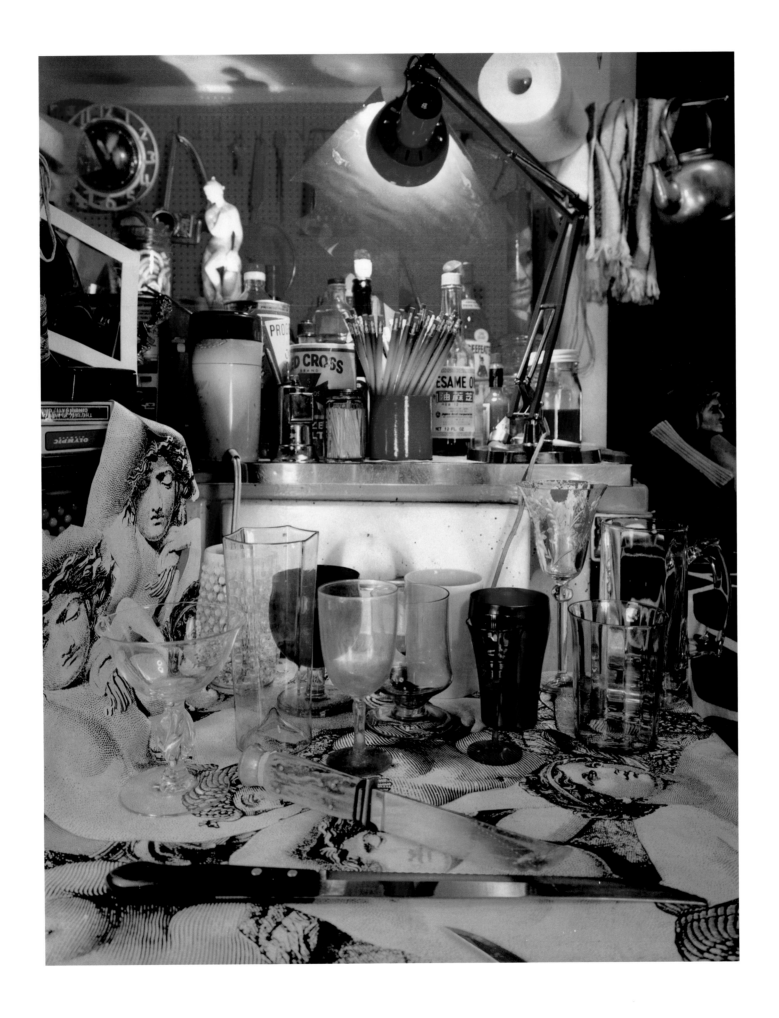

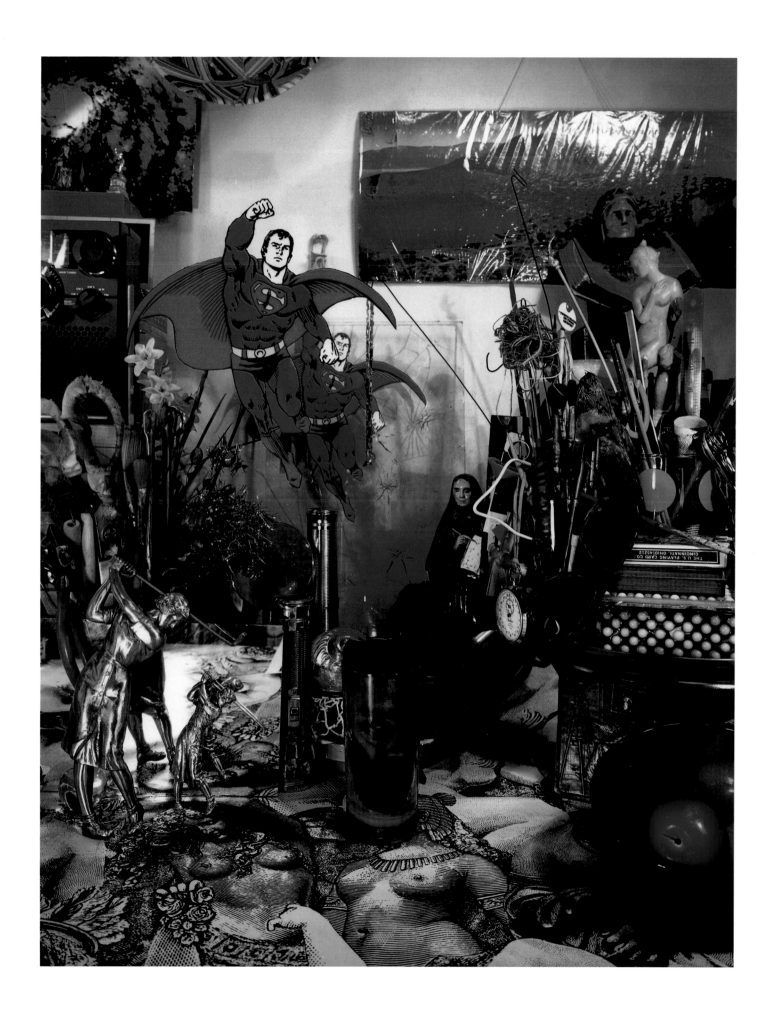

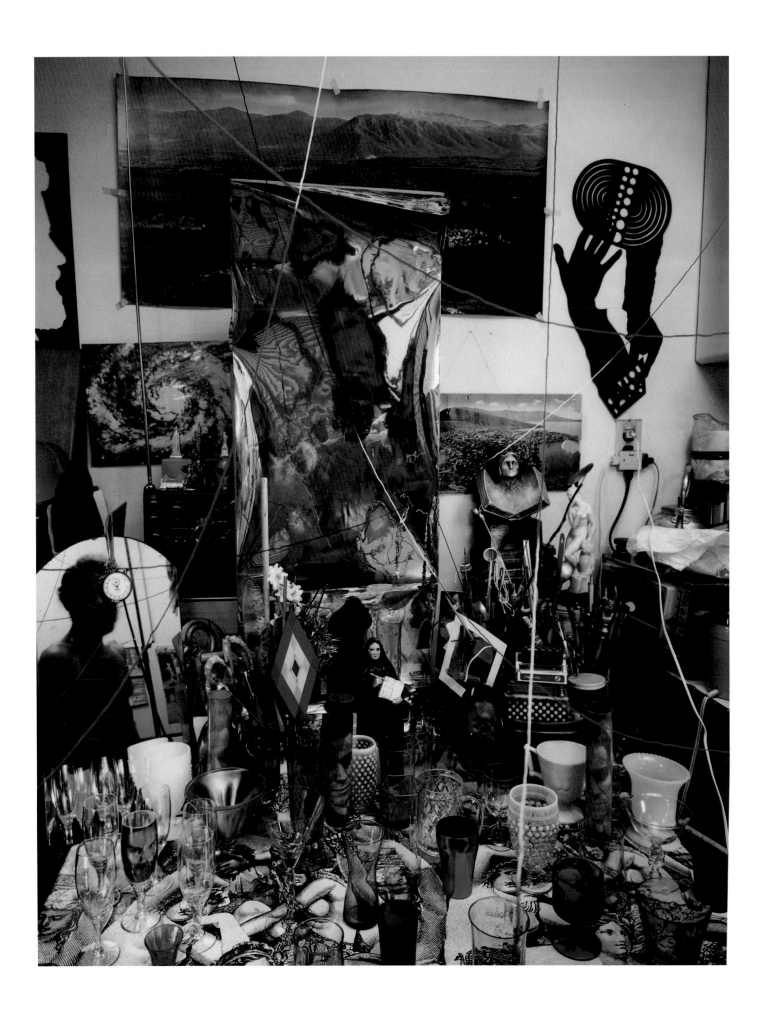

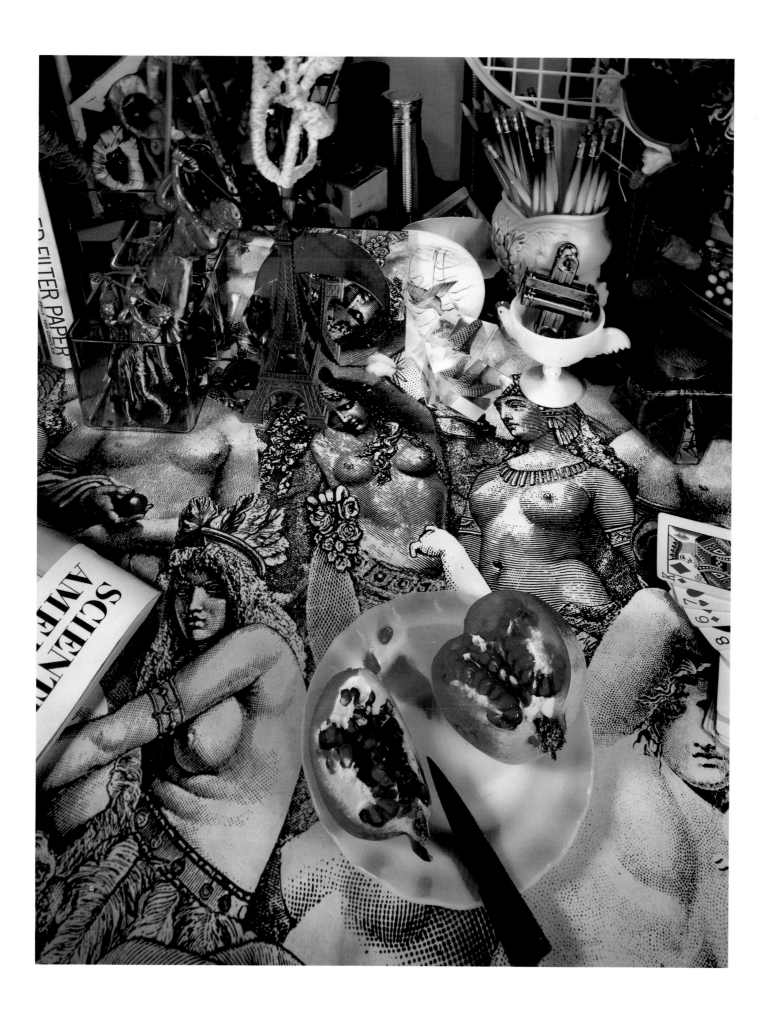

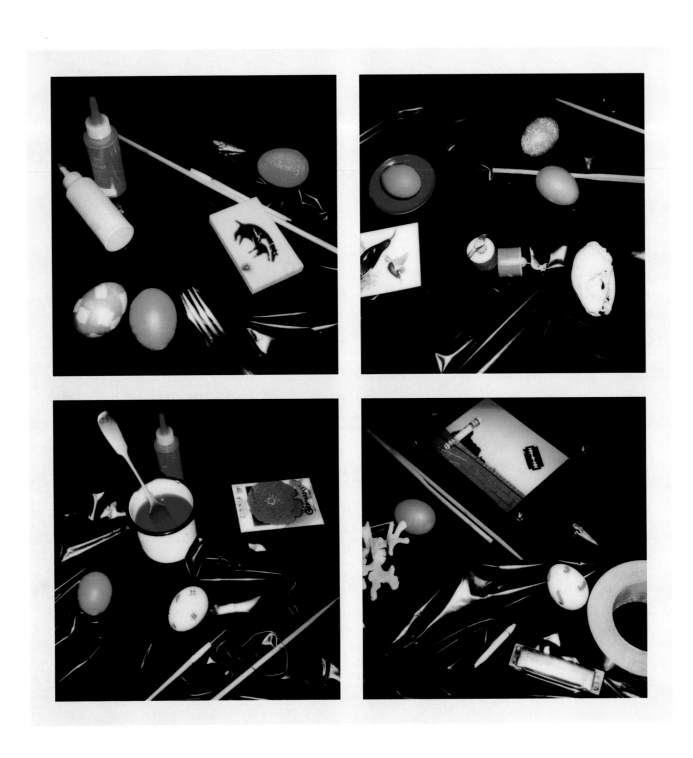

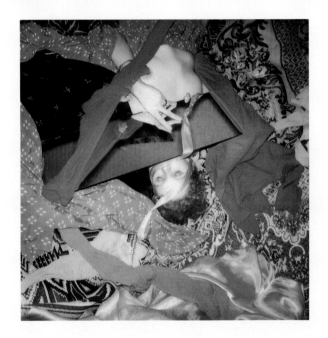

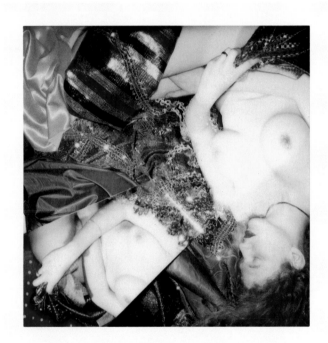

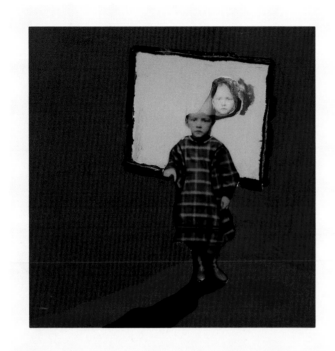

55 JOHN REUTER Untitled, 1978

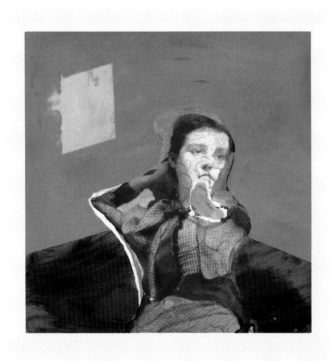

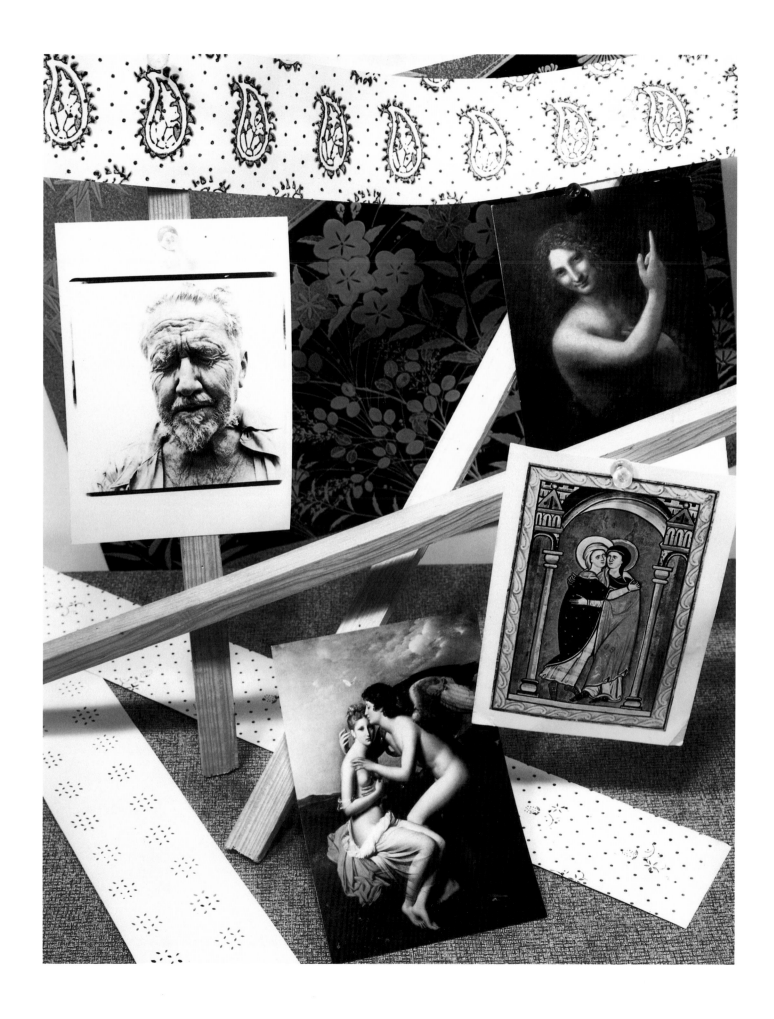

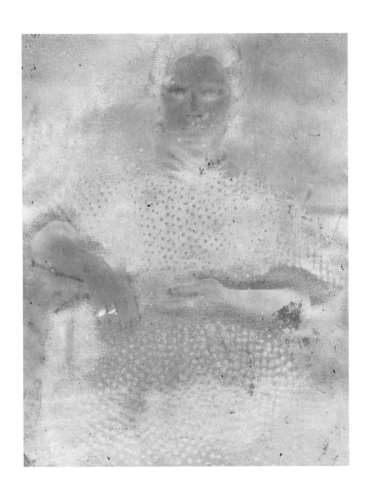

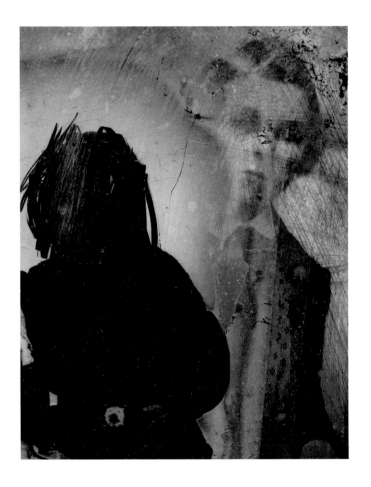

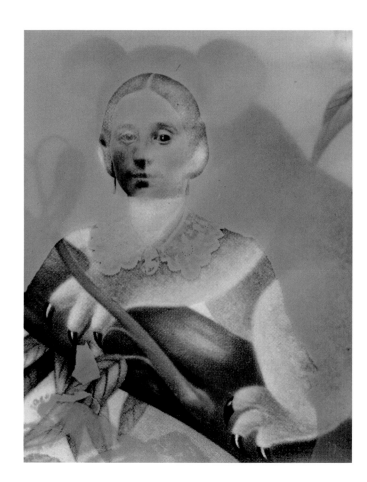

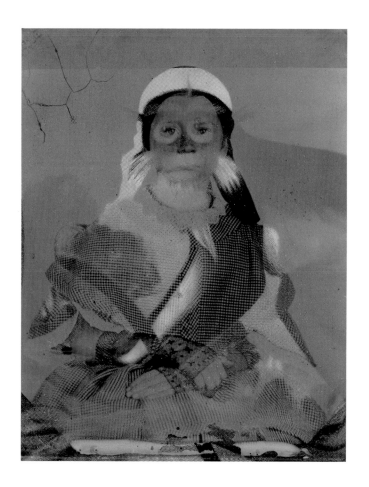

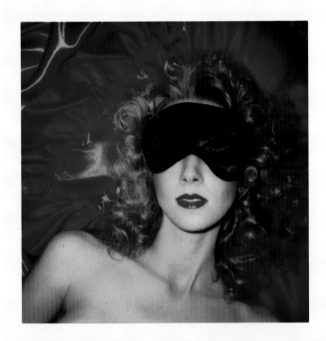

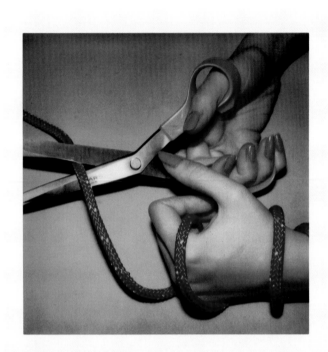

65 KENNETH McGOWAN Sink, 1978

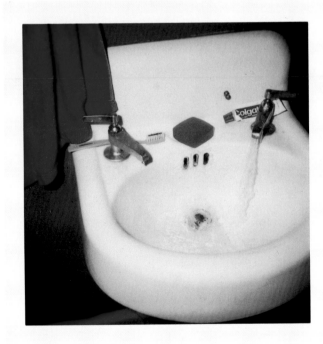

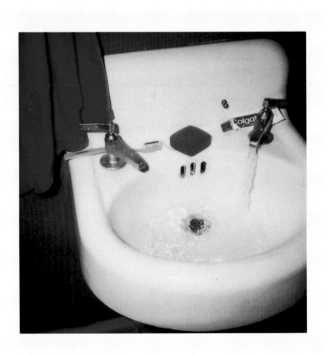

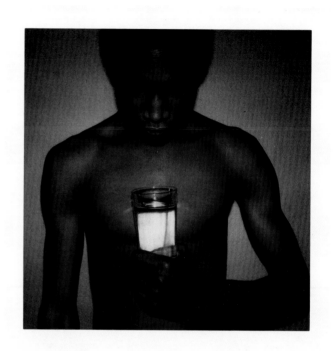

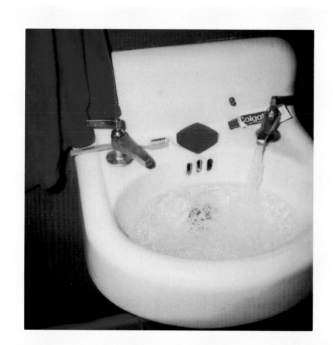

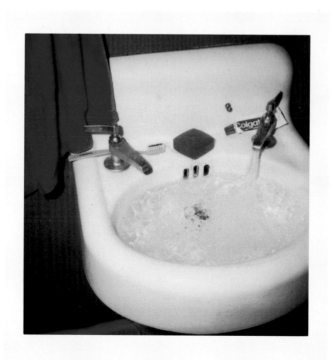

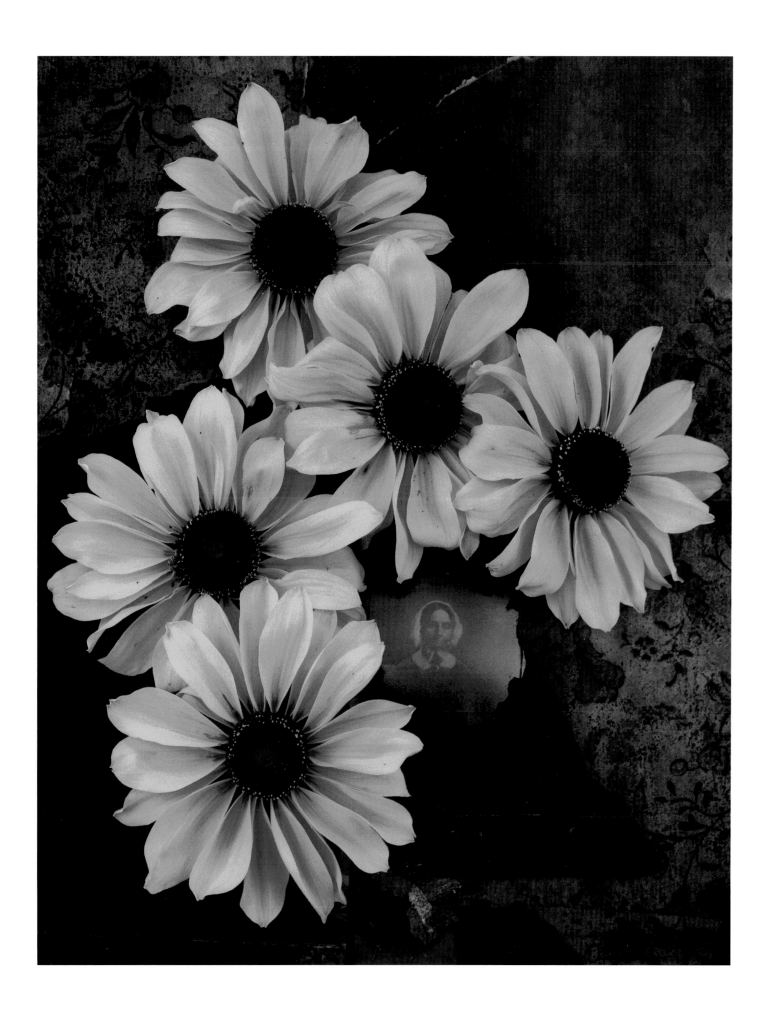

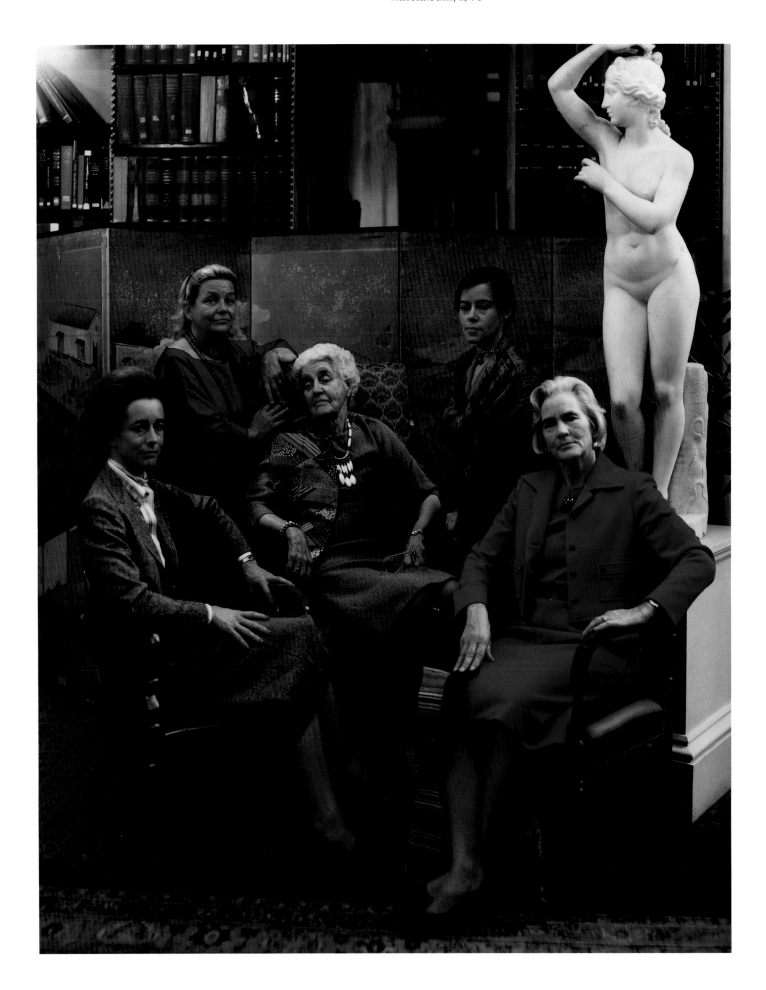

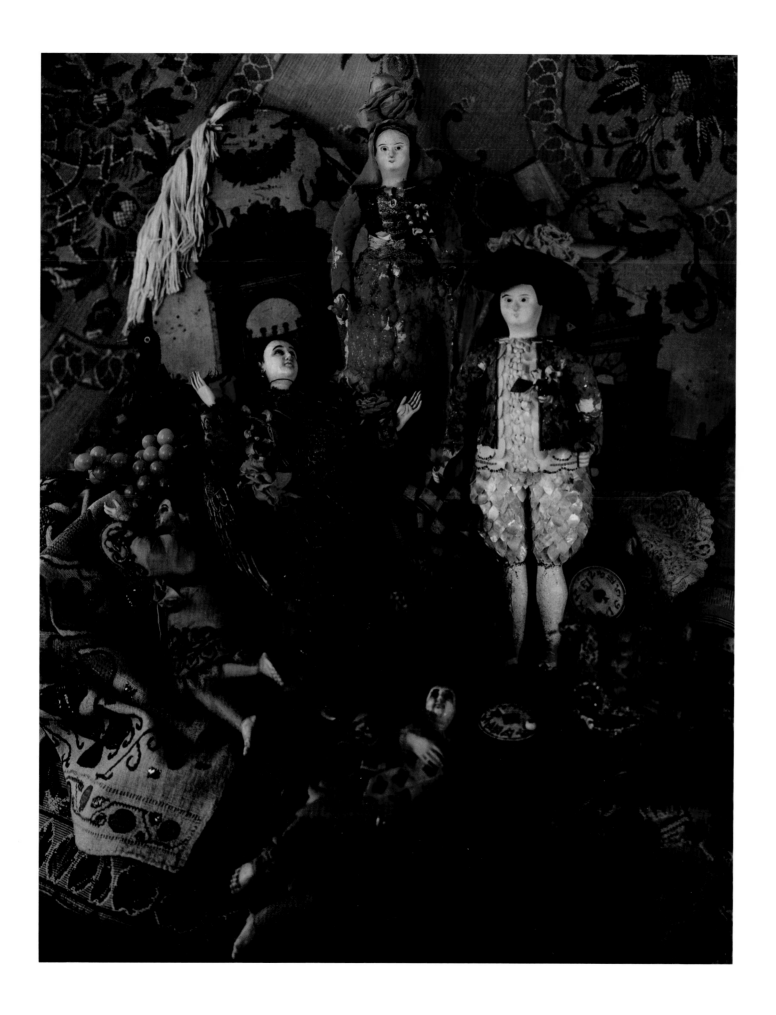

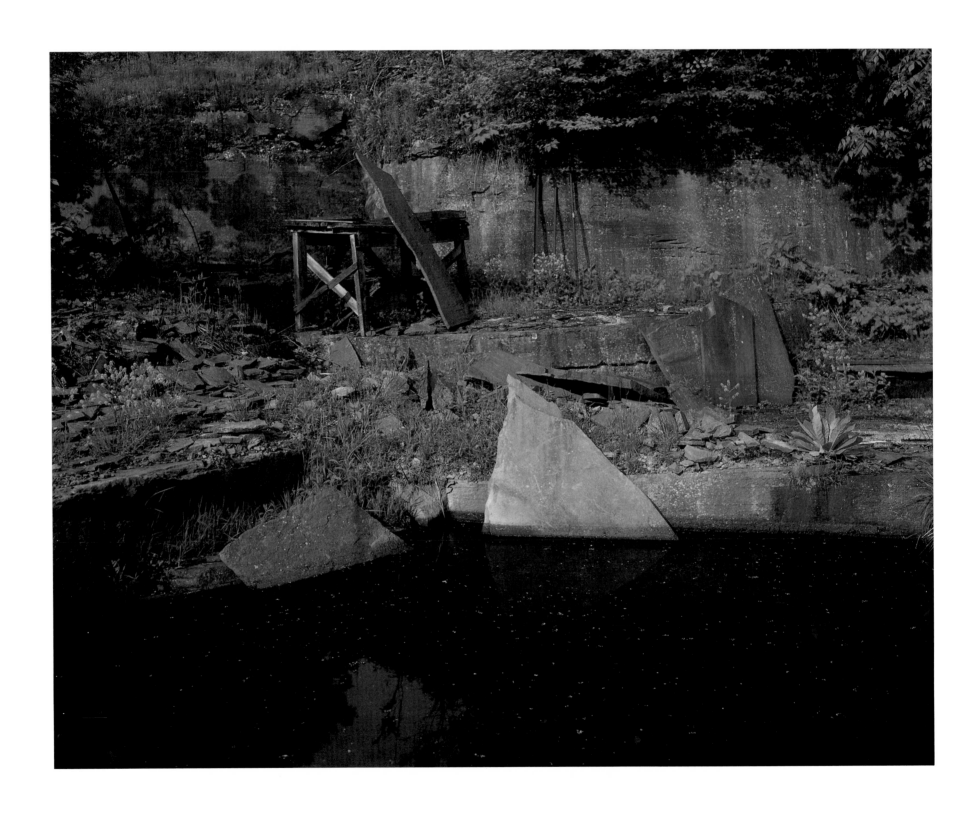

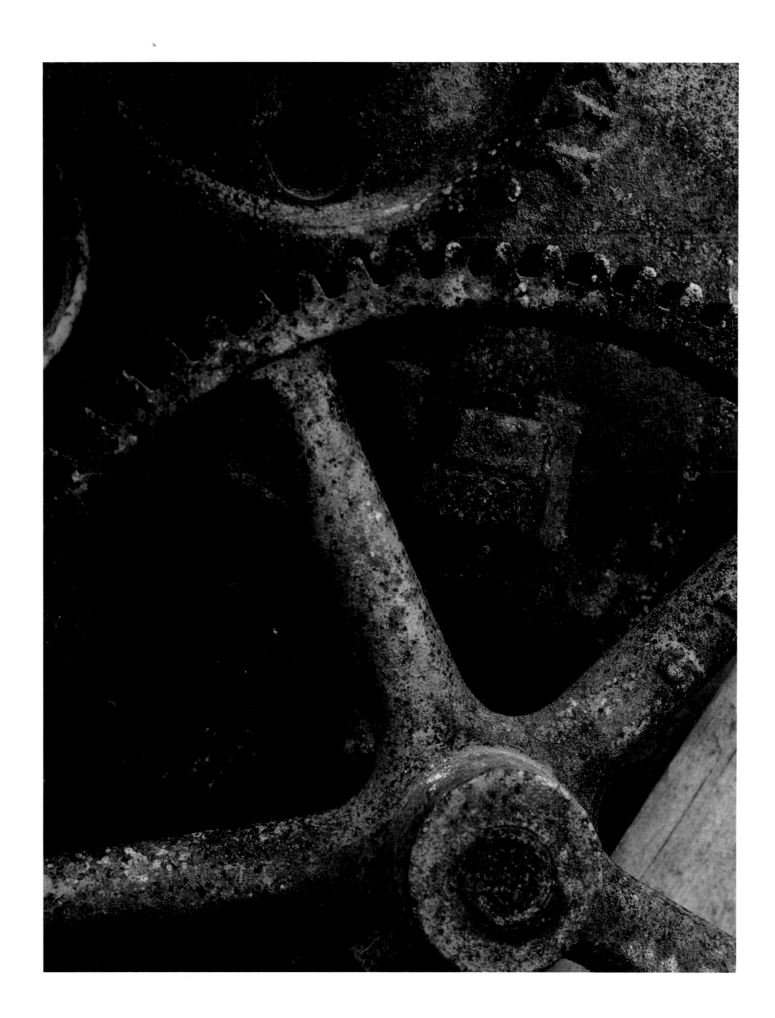

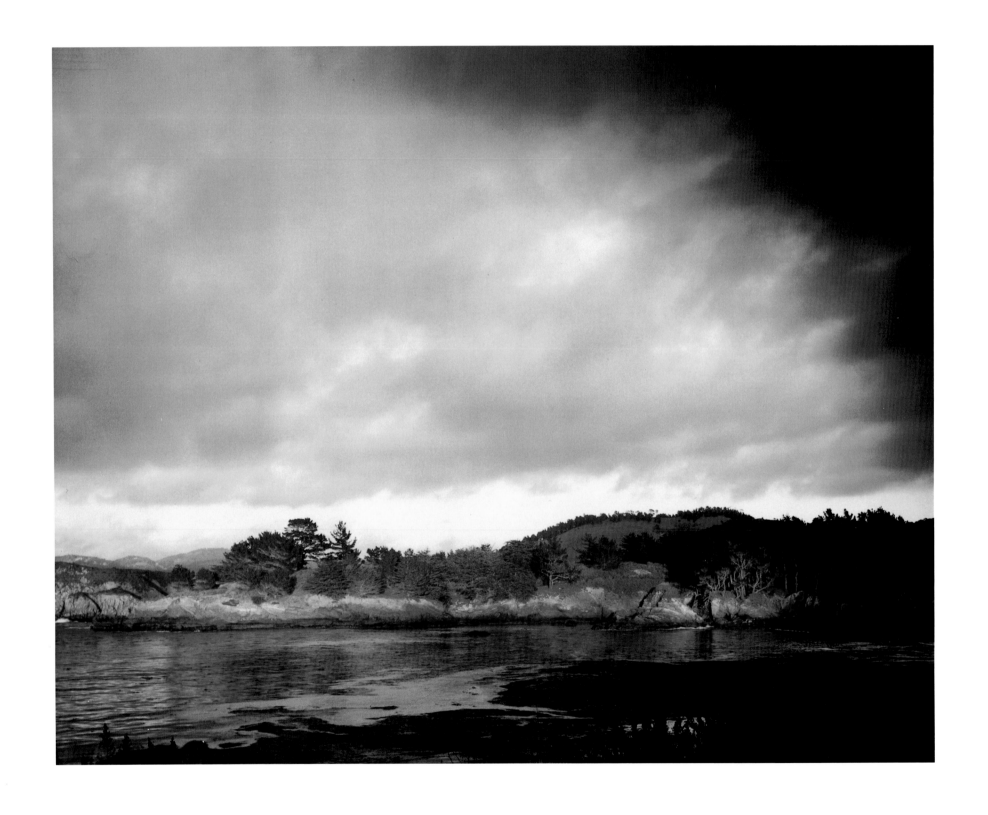

Contributing Artists

The entries on contributing artists list in the following order: place of birth, current residence, and gallery(ies) that represent the work of each artist.

All of the following cited publications are monographs.

Ansel Adams
San Francisco, Ca., 1902
Carmel, Ca.
Light Gallery, New York
selected publications:
This is the American Earth
San Francisco: Sierra Club, 1960
Ansel Adams
Dobbs Ferry, N.Y.: Morgan and Morgan, 1972
Singular Images
Dobbs Ferry, N.Y.: Morgan and Morgan, 1974
Ansel Adams: Images 1923-1974
Boston: New York Graphic Society, 1974
Photographs of the Southwest
Boston: New York Graphic Society, 1976
The Portfolios of Ansel Adams
Boston: New York Graphic Society, 1977

Best-known for his photographs of the American landscape, Adams is probably the most prominent living American photographer today. He has been a consultant to Polaroid Corporation since 1945. The 8x10 Polacolor photograph in this exhibition is one of his most recent color photographs.

Michael Bishop
Palo Alto, Ca., 1946
Rochester, N.Y.
Light Gallery, New York

Bishop has explored a wide variety of photographic materials and techniques, often taking them beyond their traditional boundaries. The 20x24 Polacolor photographs in this exhibition were made in October, 1978.

Jack Caspary
Dallas, Texas, 1943
Dallas

Caspary has used SX-70 film since 1976 and has occasionally employed it in his commercial assignments. The photographs in this exhibition were made in 1978.

Linda Connor
New York, N.Y., 1944
San Francisco, Ca.
Light Gallery, New York
publication:
Solos
Millerton, N.Y.: Apeiron, 1979

Connor is well-known for her large-format, soft focus contact prints in gold-toned black and white. An early member of the Polaroid Collection, she has explored a variety of Polaroid photographic materials for several years. The 8x10 Polacolor photographs in this exhibition were made in the spring of 1978.

Marie Cosindas
Boston, Mass.
Boston
publication:
Marie Cosindas, Color Photographs
Boston: New York Graphic Society, 1978

Among the first photographers to be invited by Polaroid Corporation to experiment with Polacolor film in 1962, Cosindas has since worked almost exclusively in Polacolor. She has contributed not only to the definition of color photography but particularly to the creative interpretation of Polacolor.

Frank Di Perna
Pittsburgh, Pa., 1947
Washington, D.C.
Diane Brown Gallery, Washington, D.C.
publication:
Frank Di Perna, Color Photographs
Washington, D.C.: Corcoran Gallery of Art, 1977

Di Perna began using SX-70 film in 1975 and became one of the first to earn himself a one-man exhibition of SX-70 prints at a major art museum when he was shown at The Corcoran Gallery of Art in June, 1977. He began working in 8x10 Polacolor in the summer of 1978.

William Eggleston
Memphis, Tenn., 1939
Memphis
Caldecot Chubb, agent, New York
publication:
William Eggleston's Guide
New York: Museum of Modern Art, 1976

Eggleston has been photographing in color since the late 1960s, recently emerging as one of America's leading contemporary color photographers. The 8x10 Polacolor photographs in this exhibition were made in the spring of 1978.

Benno Friedman
New York, N.Y., 1945
Sheffield, Mass.
Light Gallery, New York

Friedman is known for his unconventional use of black and white photography. By bleaching, toning, solarizing and generally ignoring traditional photographic technique, he has invented a personal form of photographic color. Made in the winter of 1978, the SX-70 photographs in this exhibition display a rare moment of interest in straight color photography.

John Gintoff
Meriden, Conn., 1942
Meriden

Gintoff has been making color photographs for several years and since the winter of 1978 has been working almost exclusively with SX-70 film. The photographs in this exhibition are from a continuing series called "Persian Versions."

Jan Groover
Plainfield, N.J., 1943
New York, N.Y.
Sonnabend Gallery, New York

Having photographed in color for several years, Groover is well-known for her large-scale triptychs. Recently she has been making still lifes of kitchen utensils. The 20x24 Polacolor photographs in this exhibition were made in November, 1978.

Brian Hagiwara
Little Rock, Ark., 1943
New York, N.Y.

Hagiwara has been using SX-70 film since its introduction in 1972. The photographs in this exhibition are from a continuing series of SX-70 polyptychs.

David Haxton
Indianapolis, Ind., 1943
New York, N.Y.
Sonnabend Gallery, New York

Haxton's photographic diptychs make use of seamless paper, floodlights and other studio props to explore the effects of light and color. The 20x24 Polacolor photograph in this exhibition was made in October, 1978; the 4x5 Polacolor photographs were made in preparation for the larger work.

David Hockney
Bradford, Yorkshire, England, 1937
London and the U.S.A.
André Emmerich Gallery, New York
selected publications:
David Hockney, Paintings, Prints and Drawings, 1960-1970
London: Whitechapel Art Gallery, 1970
David Hockney by David Hockney
London: Thames and Hudson, 1976

Hockney has used SX-70 film extensively as a sketching tool for his well-known works on paper and canvas. His SX-70 prints have served in the examination of his particular fascination with the visual effects of water movement. The SX-70 photographs in this exhibition were made in preparation for a series of works on paper executed at Tyler Graphics, Bedford, N.Y., in the summer of 1978.

Les Krims
New York, N.Y., 1943
Buffalo, N.Y.
Light Gallery, New York
selected publications:
Eight Photographs: Leslie Krims
New York: Doubleday and Co., 1970
The Little People of America 1971
Buffalo, N.Y.: Humpy Press, 1972
The Deerslayers
Buffalo, N.Y.: Humpy Press, 1972
The Incredible Case of the Stack O'Wheats Murders
Buffalo, N.Y.: Humpy Press, 1972
Making Chicken Soup
Buffalo, N.Y.: Humpy Press, 1972
Fictkryptokrimsographs
Buffalo, N.Y.: Humpy Press, 1975
Krims is well-known for his symbolically staged photographic fictions. Among his most celebrated work is a series of hand-manipulated SX-70 prints called "Fictkryptokrimsographs." The SX-70 photograph in this exhibition was made in 1977.

William Larson
North Tonawanda, N.Y., 1942
Wyncote, Pa.
Light Gallery, New York
publication:
Fire Flies, as transmitted by William Larson
Wyncote, Pa.: Gravity Press, 1976

Larson has contributed to the expansion of the photographic vocabulary by introducing unexpected techniques into his work, such as his use of the Teleprinter, which transmits photographic imagery by sound. Most of his recent work has been in color, using the square format. He began using SX-70 film in the spring of 1978.

Kenneth McGowan
Ogden, Utah, 1940
Los Angeles, Ca.
Castelli Uptown, New York

McGowan has worked as a color photographer for several years. Most often he employs the square format for both his creative work and his commercial assignments. He began using SX-70 film in the summer of 1978.

Roger Mertin

Bridgeport, Conn., 1942
Rochester, N.Y.
Light Gallery, New York
publication:
Records 1976-78
Chicago: Chicago Center for Contemporary Photography, 1978

Mertin has been an influential figure in contemporary photography since the late 1960s. His recent work in 8x10 Polacolor, begun in the fall of 1978, coincides with his continuing use of the view camera and a growing interest in color.

Arnold Newman

New York, N.Y., 1918
New York
Light Gallery, New York
selected publications:
Bravo Stravinsky
New York: World Publishing Co., 1967
One Mind's Eye
Boston: David R. Godine, 1974
Faces U.S.A.
Garden City, N.Y.: Amphoto, 1978

A prominent portrait photographer, Newman was among the first photographers to be invited by Polaroid Corporation to use 8x10 Polacolor in 1977. The portraits selected for this exhibition are all of fellow photographers.

Kenda North

Chicago, Ill., 1951
Breckenridge, Col.
G. Ray Hawkins Gallery, Los Angeles

North is known for her large-scale, hand colored dye-transfer prints from black and white 35mm negatives. The 20x24 Polacolor photograph in this exhibition was made in October, 1978.

Starr Ockenga

Boston, Mass., 1938
Ipswich, Mass.
Marcuse Pfeifer Gallery, New York
publications:
Mirror After Mirror
Garden City, N.Y.: Amphoto, 1976
Dressup
Danbury, N.H.: Addison House, 1978

Ockenga is noted for her informal portraits of women and young girls, often using black-and-white infrared film. She has occasionally used SX-70 film to make preliminary sketches for her portraits.

Olivia Parker

Boston, Mass., 1941
Manchester, Mass.
Vision Gallery, Boston
publication:
Signs of Life
Boston: David R. Godine, 1978

Trained as a painter, Parker took up photography in 1970. Until she began working in 8x10 Polacolor in the spring of 1978, she had worked in the 4x5 and 5x7 formats, making black-and-white still lifes, split-toned brown and blue.

Bruce Patterson

Dayton, Ohio, 1950
Dayton
Robert Freidus Gallery, New York

Patterson often uses one photograph as a starting point for a series of visual ideas, employing paint, paste, and scissors to create his variations. The 8x10 Polacolor photographs in this exhibition were made in the spring of 1978.

Rosamond Wolff Purcell

Boston, Mass., 1942
Medford, Mass.
Marcuse Pfeifer Gallery, New York
publication:
A Matter of Time
Boston: David R. Godine, 1975

Purcell has been working almost exclusively with Polaroid photographic materials since 1969. The 4x5 Polacolor photographs in this exhibition are among her first color work, dating from the fall of 1977. The technique is her own invention, sandwiching nineteenth-century ambrotypes with Victorian illustrations and other scraps.

John Reuter

Chicago, Ill., 1953
Malden, Mass.

Reuter has worked with SX-70 film since 1975. He manipulates his photographs by peeling part of the original emulsion away and replacing it with other materials, such as magazine illustrations and acrylic paint. The SX-70 photographs in this exhibition reflect a recent interest in nineteenth-century photographs.

Don Rodan
Cincinnati, Ohio, 1950
New York, N.Y.
Castelli Uptown, New York

Rodan has used SX-70 film exclusively for the past two years. Both his commercial assignments and creative work in SX-70 film fall into an allegorical category. The photographs in this exhibition are from an extensive series entitled "The Greek Myths."

Lucas Samaras
Kastoria, Macedonia, Greece, 1936
New York, N.Y.
The Pace Gallery, New York
selected publications:

Lucas Samaras by Lucas Samaras
New York: Whitney Museum of American Art, The Pace Gallery, 1971

Lucas Samaras
New York: Abrams Publications, 1975

Lucas Samaras, Photo-Transformations
New York: E.P. Dutton and Co., Inc., 1975

Among the first artists to experiment with Polaroid film as early as 1969, Samaras began in 1973 his well-known series of SX-70 self-portraits called "Photo-Transformations." He is an artist of all media, but his use of photography, specifically Polaroid film, has significantly broadened the scope and potential of creative color photography. His recent work in 8x10 Polacolor began in the summer of 1978. The photographs in this exhibition are among the first in an extensive series.

Victor Schrager
Bethesda, Md., 1950
New York, N.Y.
Robert Freidus Gallery, New York

Schrager began using 8x10 Polacolor in the fall of 1978. The photographs in this exhibition follow an extensive and continuing series of 8x10 black-and-white contact prints of art reproductions in still-life arrangement.

Sharon Smith
Dallas, Texas, 1951
New York, N.Y.

Much of Smith's work with SX-70 film since 1977 has been concerned with beach society. The photographs in this exhibition, made in the summer of 1977, are part of an extensive series from Coney Island.

Eve Sonneman
Chicago, Ill., 1946
New York, N.Y.
Castelli Uptown, New York
The Texas Gallery, Houston
publication:
Real Time
New York: Printed Matter, 1976

Sonneman, well-known for her photographic diptychs, has recently been working exclusively in color. She began using SX-70 film in the spring of 1978.

Joel Sternfeld
New York, N.Y., 1944
Belle Harbor, N.Y.

Using both 35mm and a 4x5 press camera, Sternfeld has been making candid street photographs in color since 1976. The 4x5 Polacolor photographs in this exhibition were made in the spring of 1978.

Willard Van Dyke
Denver, Col., 1906
New York, N.Y.
Lee Witkin Gallery, New York
Stephen Wirtz Gallery, San Francisco

One of the founders of Group f/64 in California, Van Dyke left photography to pursue a career as a filmmaker, for a time. He did not return to still photography until early in 1978. Since then, well acquainted with view-camera technique, he has used 8x10 Polacolor exclusively. These are his first color photographs.

Peter Von Zur Muehlen
Berlin, Germany, 1939
Reston, Va.
Marcuse Pfeifer Gallery, New York
Wolfe Street Gallery, Washington, D.C.

Von Zur Muehlen began working with SX-70 film in 1976. He launched his photographic career as a black-and-white photographer, but for the past two years he has used SX-70 film exclusively.

Ansel Adams

Point Lobos, Late Evening, California, 1977	8x10

Michael Bishop

Excess Still Life, 1978	20x24
Copying Windows and Mirrors, 1978	20x24

Jack Caspary

Untitled, 1978	SX-70
Untitled, 1978	SX-70
Untitled, 1978	SX-70
Untitled, 1978	SX-70

Linda Connor

Untitled, 1978	8x10
Untitled, 1978	8x10

Marie Cosindas

Conger Metcalf Still Life, 1976	8x10
Group Portrait, Boston, Athenaeum, 1978	8x10

Frank Di Perna

Overgrown Fence, Great Falls, Va., 1977	SX-70
Car Wash, Cape Cod, Mass., 1977	SX-70
Urbanscape, Washington, D.C., 1977	SX-70
Bicycle, Rehoboth Beach, Del., 1976	SX-70
Bedroom, Tenants Harbor, Me., 1977	SX-70
Pipe, Belfast, Me., 1977	SX-70
Wrapped couch, Washington, D.C., 1978	8x10
Couch and nightgown, Arlington, Va., 1978	8x10

William Eggleston

Untitled, 1978	8x10
Untitled, 1978	8x10

Benno Friedman

Untitled, 1978	SX-70
Untitled, 1978	SX-70
Untitled, 1978	SX-70
Untitled, 1978	SX-70
Untitled, 1978	SX-70
Untitled, 1978	SX-70

John Gintoff

from "Persian Versions", 1978	SX-70
from "Persian Versions", 1978	SX-70
from "Persian Versions", 1978	SX-70
from "Persian Versions", 1978	SX-70

Jan Groover

Untitled, 1978	20x24
Untitled, 1978	20x24

Brian Hagiwara

Plastic, Still Life, 1978	SX-70 Polyptych
Easter, 1978	SX-70 Polyptych
Mexican Blanket, 1978	SX-70 Polyptych

David Haxton

Untitled, 1978	20x24 Diptych
Study for 20x24, 1978	4x5 Diptych
Study for 20x24, 1978	4x5 Diptych

David Hockney

Untitled, 1978	SX-70
Untitled, 1978	SX-70
Untitled, 1978	SX-70
Untitled, 1978	SX-70

Les Krims

Untitled, 1977	SX-70

William Larson

Hand-colored SX-70, 1978	SX-70
Hand-colored SX-70, 1978	SX-70
SX-70 Silver Print, 1978	SX-70
SX-70 Silver Print, 1978	SX-70
SX-70 Still Life, 1978	SX-70
SX-70 Still Life, 1978	SX-70

Kenneth McGowan

Frying Egg, 1978	SX-70 Polyptych
Sink, 1978	SX-70 Polyptych

Roger Mertin

Boston, Mass., 1978	8x10
Rochester, N.Y., 1978	8x10
Rochester, N.Y., 1978	8x10
Eastover Farm, Ct., 1978	8x10

Arnold Newman

Mr. and Mrs. Roman Vishniac, 1977	8x10
Eva Rubenstein, 1977	8x10
David Hockney, 1978	8x10
Bill Brandt, 1978	8x10

Kenda North

Untitled, 1978	20x24

Starr Ockenga

Untitled, 1978	SX-70

Olivia Parker	
Untitled, 1978	8x10
Untitled, 1978	8x10
Untitled, 1978	8x10
Untitled, 1978	8x10
Untitled, 1978	8x10
Untitled, 1978	8x10

Bruce Patterson	
Untitled, 1978	8x10
Untitled, 1978	8x10
Untitled, 1978	8x10
Untitled, 1978	8x10

Rosamond Wolff Purcell	
Untitled, 1978	4x5
Untitled, 1978	4x5
Untitled, 1978	4x5
Untitled, 1978	4x5
Untitled, 1978	4x5
Untitled, 1978	4x5

John Reuter	
Untitled, 1978	SX-70
Untitled, 1978	SX-70
Untitled, 1978	SX-70
Untitled, 1978	SX-70
Untitled, 1978	SX-70
Untitled, 1978	SX-70

Don Rodan	
Ambidextra, 1977	SX-70
Atropos, 1977	SX-70
Hypnos, 1977	SX-70
Narcissus, 1977	SX-70

Lucas Samaras	
Untitled, 1978	8x10
Untitled, 1978	8x10
Untitled, 1978	8x10
Untitled, 1978	8x10
Untitled, 1978	8x10
Untitled, 1978	8x10

Victor Schrager	
Untitled, 1978	8x10
Untitled, 1978	8x10

Sharon Smith	
from "Coney Island", 1977	SX-70
from "Coney Island", 1977	SX-70
from "Coney Island", 1977	SX-70
from "Coney Island", 1977	SX-70
from "Coney Island", 1977	SX-70

Eve Sonneman	
Len's Lunch, Clovis, N.M., 1978	
Bruce's Bar-B-Q, Oneonta, N.Y., 1978	

Joel Sternfeld	
Untitled, 1978	4x5
Untitled, 1978	4x5
Untitled, 1978	4x5
Untitled, 1978	4x5

Willard Van Dyke	
Untitled, 1978	8x10
Untitled, 1978	8x10

Peter Von Zur Muehlen	
Untitled, 1978	SX-70
Untitled, 1978	SX-70
Untitled, 1978	SX-70
Untitled, 1978	SX-70
Untitled, 1978	SX-70
Untitled, 1978	SX-70

The text is typeset in ITC Garamond Light by Typographic House, Boston.
The book is printed by Acme Printing Co. on 100 lb. Cameo Dull
and bound by Horowitz and Son.
Design: Victor Cevoli
Production: Alison Gustafson
Edited by Yong-Hee Last